The Beauty of Geology: Art of Geology Mapping
in China Over a Century

Chenyang Li • Liqiong Jia • Xuan Wu
Editors

The Beauty of Geology: Art of Geology Mapping in China Over a Century

OPEN

Editors
Chenyang Li
Development and Research Center of China
Geological Survey (National Geological
Archives of China)
Xicheng District, Beijing, P.R. China

Liqiong Jia
Development and Research Center of China
Geological Survey (National Geological
Archives of China)
Xicheng District, Beijing, P.R. China

Xuan Wu
Development and Research Center of China
Geological Survey (National Geological
Archives of China)
Xicheng District, Beijing, P.R. China

ISBN 978-981-13-3785-7 ISBN 978-981-13-3786-4 (eBook)
https://doi.org/10.1007/978-981-13-3786-4

Library of Congress Control Number: 2018966875

© The Editor(s) (if applicable) and The Author(s) 2019. This book is an open access publication.
Open Access This book is licensed under the terms of the Creative Commons Attribution 4.0 International License (http://creativecommons.org/licenses/by/4.0/), which permits use, sharing, adaptation, distribution and reproduction in any medium or format, as long as you give appropriate credit to the original author(s) and the source, provide a link to the Creative Commons licence and indicate if changes were made.
The images or other third party material in this book are included in the book's Creative Commons licence, unless indicated otherwise in a credit line to the material. If material is not included in the book's Creative Commons licence and your intended use is not permitted by statutory regulation or exceeds the permitted use, you will need to obtain permission directly from the copyright holder.
The use of general descriptive names, registered names, trademarks, service marks, etc. in this publication does not imply, even in the absence of a specific statement, that such names are exempt from the relevant protective laws and regulations and therefore free for general use.
The publisher, the authors, and the editors are safe to assume that the advice and information in this book are believed to be true and accurate at the date of publication. Neither the publisher nor the authors or the editors give a warranty, express or implied, with respect to the material contained herein or for any errors or omissions that may have been made. The publisher remains neutral with regard to jurisdictional claims in published maps and institutional affiliations.

This Springer imprint is published by the registered company Springer Nature Singapore Pte Ltd.
The registered company address is: 152 Beach Road, #21-01/04 Gateway East, Singapore 189721, Singapore

Acknowledgment

Thanks go to the "National Geological Data Convergence and Collection" project of China Geological Survey (Grant No. DD20160348) that supported funding to make this atlas a reality. We would like to thank Mr. Yan Guangsheng, Mr. Shi Junfa, Mrs. Xing Lixia, Mr. Chen Hui and Mrs. Liu Yayan, who all come from China Geological Survey, given guidance for the preparation of the atlas. We also would like to express our appreciation to all those who helped us during the preparation and publication of this atlas. To Mr. Xu Yong, Mr. Zhang Haiqi, Mr. Tan Yongjie, Development and Research Center of China Geological Survey, for their technical support;to Mr. Qiang Xin, Mr. Huang Bing and Mrs. Zhang Qian, Development and Research Center of China Geological Survey, for choosing geological maps; to Mrs. Wang Xueping and Mrs. Wang Chunning, National Geological Library of China, for selecting hand-drawn drawings. We would like to extend our thanks to the calligrapher Kou Kerang, *Chinese Painting* & Calligraphy editor Liu Guang, for their art direction.

Contents

1 **Introduction** .. 1
Chenyang Li, Liqiong Jia, and Xuan Wu

2 **Initiation Period (1914-1934): Geologists' Artistic Accomplishment Reflected by Hand-Drawn Maps** 3
Chenyang Li, Guo Liu, Ruiyang Yu, Hui Guo, and Fanyu Qi

3 **Exploration Period (1935-1953): The First Step Toward Standardization** .. 22
Liqiong Jia, Xiaolei Li, Yuntao Shang, Xuezheng Gao, and Jie Meng

4 **Growth Period (1954-1994): Maps Displaying More Information and Printed in More Standard Way** 49
Liqiong Jia, Zhaoyu Kong, Xuezheng Gao, Hui Guo, Xiaolei Li, and Chunzhen He

5 **Leaping Forward Period (1995 to Present): Moving into Digital Mapping and Digital Cartography Era** 103
Xuan Wu, Fanyu Qi, Guo Liu, Yuntao Shang, and Jie Meng

Contributors

Xuezheng Gao Development and Research Center of China Geological Survey (National Geological Archives of China), Xicheng District, Beijing, P.R. China

Hui Guo Development and Research Center of China Geological Survey (National Geological Archives of China), Xicheng District, Beijing, P.R. China

Chunzhen He Development and Research Center of China Geological Survey (National Geological Archives of China), Xicheng District, Beijing, P.R. China

Liqiong Jia Development and Research Center of China Geological Survey (National Geological Archives of China), Xicheng District, Beijing, P.R. China

Zhaoyu Kong Development and Research Center of China Geological Survey (National Geological Archives of China), Xicheng District, Beijing, P.R. China

Chenyang Li Development and Research Center of China Geological Survey (National Geological Archives of China), Xicheng District, Beijing, P.R. China

Xiaolei Li Development and Research Center of China Geological Survey (National Geological Archives of China), Xicheng District, Beijing, P.R. China

Guo Liu National Geological Library of China/Geoscience Documentation Center, China Geological Survey, Haidian District, P.R. China

Jie Meng Development and Research Center of China Geological Survey (National Geological Archives of China), Xicheng District, Beijing, P.R. China

Fanyu Qi Development and Research Center of China Geological Survey (National Geological Archives of China), Xicheng District, Beijing, P.R. China

Yuntao Shang Development and Research Center of China Geological Survey (National Geological Archives of China), Xicheng District, Beijing, P.R. China

Xuan Wu Development and Research Center of China Geological Survey (National Geological Archives of China), Xicheng District, Beijing, P.R. China

Ruiyang Yu Development and Research Center of China Geological Survey (National Geological Archives of China), Xicheng District, Beijing, P.R. China

Introduction

Chenyang Li, Liqiong Jia, and Xuan Wu

In 1916, the first generation of geological graduates entered the China Geological Survey and opened a new era of geological survey in China. Over the past 100 years, generations of geologists have made outstanding contributions to the geological survey and prospecting for China's prosperity. They measure the ground, search for treasures, explore the earth, and engrave the beautiful mountains and rivers. As geologists, they completed many beautiful geological maps with the skill of the painter. These maps carry geological information in a scientific way and display a profound artistic aesthetics, reflecting the geologists' good artistic accomplishment, romantic work feelings, and the inheritance and development of geological spirit from generation to generation.

The National Geological Archives of China have collected millions of geological maps, among which the outstanding works can be called artworks. Hand-drawn drawings have distinct lines, reasonable composition, elegant colors and meticulous painters; computer drawings are rich in content, bright colors, standard drawing, and exquisite decoration. This atlas has selected more than 100 geological maps. It integrates artistic, ornamental, and scientific features. With the development of geological mapping of China in the past century as the main line, this atlas displays geological maps and hand-drawn sketches from the perspective of art appreciation.

Based on the development of geological mapping, the atlas can be divided into four stages: initiation (from 1914 to 1934), exploration (from 1935 to 1953), growth (from 1954 to 1994) and leap (from 1995 to present). The atlas systematically shows the development and evolution of geological mapping in China, and thus explores the development and changes of geological survey in the past 100 years. These maps carry geological information in a scientific way, and display a profound artistic aesthetics, reflecting the geologists' good artistic accomplishment and romantic work feelings, showing the inheritance and development of geological spirit from generation to generation.

C. Li (✉) · L. Jia · X. Wu
Development and Research Center of China Geological Survey
(National Geological Archives of China),
Xicheng District, Beijing, P.R. China
e-mail: chenyang@mail.cgs.gov.c

© The Author(s) 2019
C. Li et al. (eds.), *The Beauty of Geology:Art of Geology Mapping in China Over a Century*,
https://doi.org/10.1007/978-981-13-3786-4_1

Open Access This chapter is licensed under the terms of the Creative Commons Attribution 4.0 International License (http://creativecommons.org/licenses/by/4.0/), which permits use, sharing, adaptation, distribution and reproduction in any medium or format, as long as you give appropriate credit to the original author(s) and the source, provide a link to the Creative Commons licence and indicate if changes were made.

The images or other third party material in this chapter are included in the chapter's Creative Common slicence, unless indicated otherwise ina credit line to the material. If material is not included in the chapter's Creative Commons licence and your intended use is not permitted by statutory regulation or exceeds the permitted use, you will need to obtain permission directly from the copyright holder.

Initiation Period (1914-1934): Geologists' Artistic Accomplishment Reflected by Hand-Drawn Maps

Chenyang Li, Guo Liu, Ruiyang Yu, Hui Guo, and Fanyu Qi

In 1903, Zhou Shuren(pseudonym is Lu Xun) said in his *Geological Theory of China*: "Observe the national conditions is not a difficult task. There is no home-made precise geological map in its territory and its city of a non-civilized country". In 1906, the *Complete Map of China's Mineral Resources* compiled by Gu Lang and Zhou Shuren is the earliest geological map in China.

From 1913 to 1919, Zhang Hongzhao, Ding Wenjiang and Weng Wenhao, the founders of China's geological cause, led the teachers and students of China Geological Survey to carry out geological and mineral survey and mapping work in Beijing Xishan, Hebei Province, Shandong Province and other places. They successively compiled geological maps of various scales, such as the *Geological Map of Xishan, Beijing*. In the 1920s, three 1:1,000,000 geological maps were compiled and published: *1:1,000,000 China Geological Map and Instructions (Beijing-Jinan Sheet), 1:1,000,000 China Geological Map and Instructions (Taiyuan-Yulin Sheet),* and *1:1,000,000 China Geological Map and Instructions (Nanjing-Kaifeng Sheet)*. In the initial stage, geological predecessors compiled many representative geological maps of great significance, which laid the first foundation for future geological mapping in China.

At this stage, geological maps are almost hand-painted, with relatively simple lines, and mostly monochrome;polychromatic maps were painted mainly with watercolor pigments, and the used paper was light and rough. There is no standard for geological mapping, and the scale is mostly written description, many of which are bilingual, in Chinese and English. Most of the maps are regional and mineral geological maps. Hand drawn geological map reflects the personal artistic accomplishment of the geological predecessors.

C. Li (✉) · R. Yu · H. Guo · F. Qi
Development and Research Center of China Geological Survey (National Geological Archives of China),
Xicheng District, Beijing, P.R. China
e-mail: chenyang@mail.cgs.gov.cn

G. Liu
National Geological Library of China/Geoscience Documentation Center, China Geological Survey,
Haidian District, P.R. China

© The Author(s) 2019
C. Li et al. (eds.), *The Beauty of Geology: Art of Geology Mapping in China Over a Century*,
https://doi.org/10.1007/978-981-13-3786-4_2

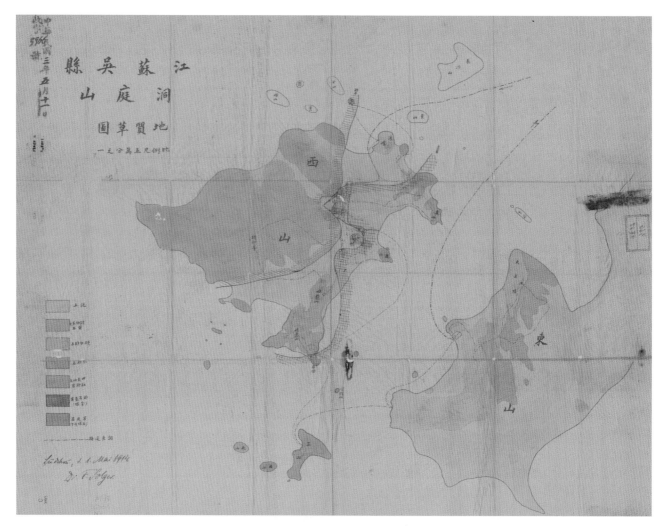

Fig. 2.1 Geological sketch map of Mt. Dongting, Wuxian County, Jiangsu Province[1]

Representing one of the earliest regional geological maps collected by the National Geological Archives of China (NGAC), this sketch depicts geological conditions in the vicinity of Mt. Dongting. The sketch's lines are distinct, and its gouache colors elegant. The paper is thin. The content of the sketch is simple, with legends and scale but no compass rose. The text that accompanies the map was written by Chinese writing brush (Fig. 2.1).

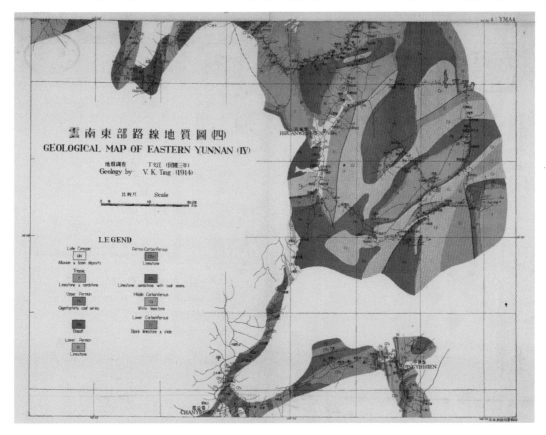

Fig. 2.2 Geological map of eastern Yunnan[2] (Source: China's first field geological map)

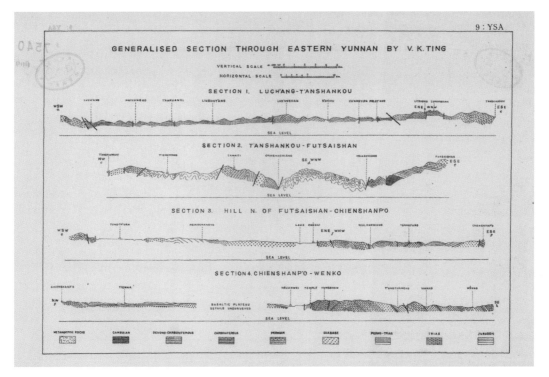

Fig. 2.3 Generalised section through eastern Yunnan by V.K. Ting[3](Source: China's first field geological map)

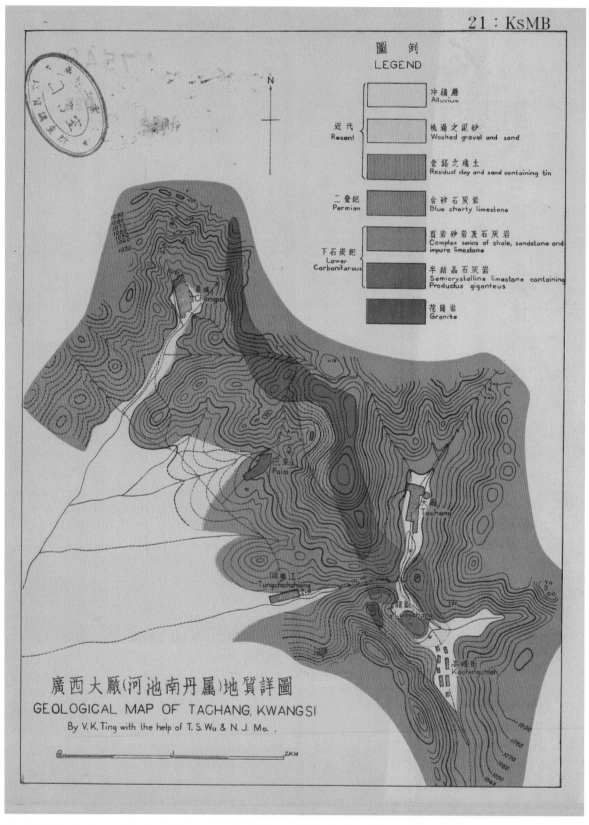

Fig. 2.4 Geological map of Dachang, Guangxi province[4](Source: China's first field geological map)

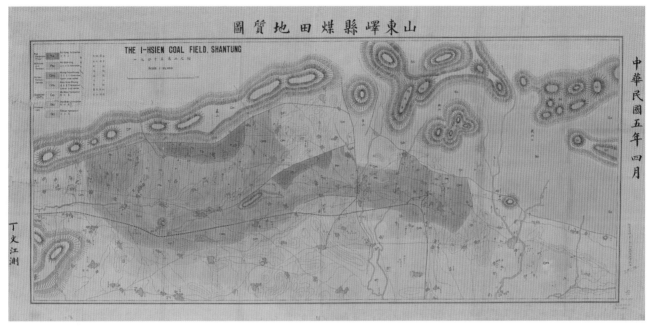

Fig. 2.5 Geological map of coalfield of Yixian, Shandong province[5](Source: China's first field geological map)

In 1914, Ding et al. traveled to Yunnan, Guizhou, Sichuan Provinces, and other destinations to conduct geological surveys. During the expedition, they compiled several geological maps and profiles as well as geological maps of mining areas in Guangxi and Shandong provinces, pioneering the development of geological mapping through field surveys in China(Figs. 2.2, 2.3, 2.4 and 2.5).

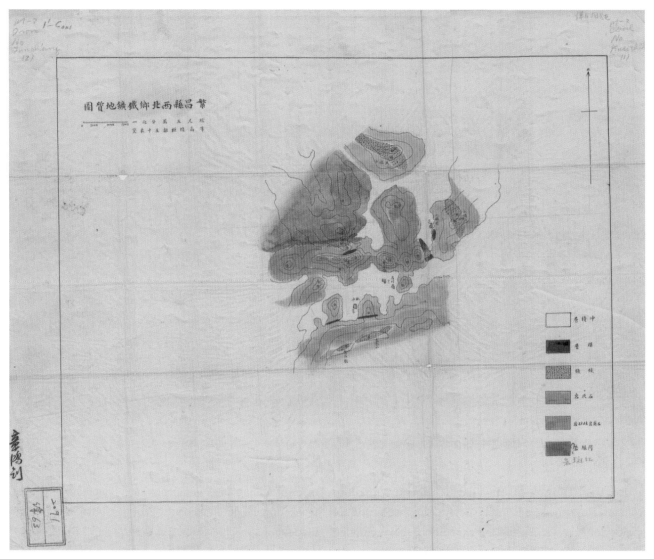

Fig. 2.6 Geological map of iron ore deposit in Xibei Township, Fanchang County[6]

This geological map of an iron ore deposit was drawn by prominent Chinese geologist Hongzhao Zhang on thin, light paper with colors in gouache. The content of the map is simple, the lines are distinct, and its colors are vivid. A legend, scale, and compass rose are included(Fig. 2.6).

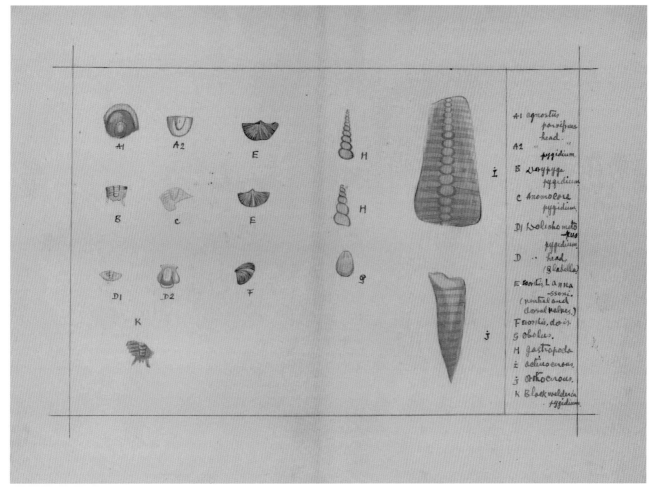

Fig. 2.7 Sketches of ancient creature's fossils [7]

These sketches depict ancient creatures innatural light using dark lines and rich textures(Fig. 2.7).

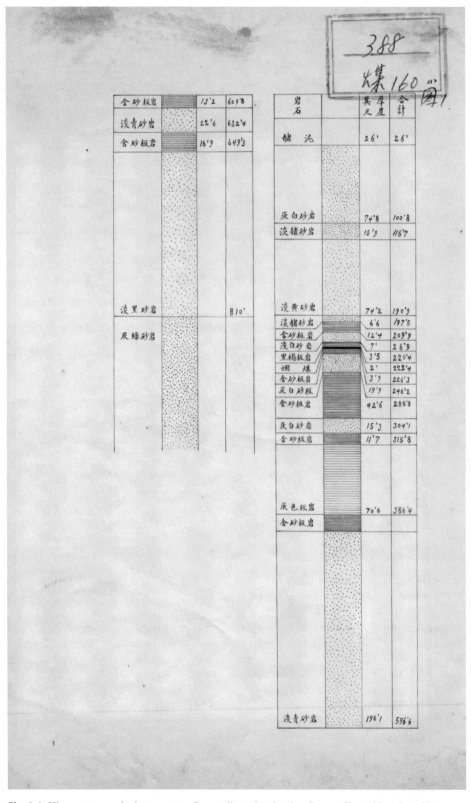

The histograms were drawn by WengWenhao, one of the earliest modern Chinese geologists. The drawings are elegant, precise and detail-oriented. The yellowed paper possesses old-fashioned charm(Fig. 2.8).

Fig. 2.8 Histograms attached to report on Boyangjian mine, Leping County, Jiangxi Province [8]

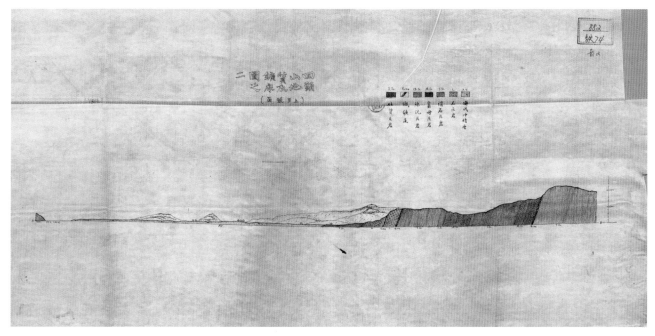

Fig.2.9 Geology and mineral deposits map of Mt. Huitou (Part II) [9]

Details are properly portrayed with smooth lines. Large areas of blank space and rolling hills highlight the map's theme. The steadily rising gentle terrain on the left of the maprecalls the mystical atmosphere of ascroll painting of rivers and mountains. The sophisticated narrative technique makes the viewer feel as though a complex story has suddenly broken off, filling the plain picture with rhythmic tension. Rather than a geological profile, the map is more like a painting of a long expanse of rivers and mountains(Fig. 2.9).

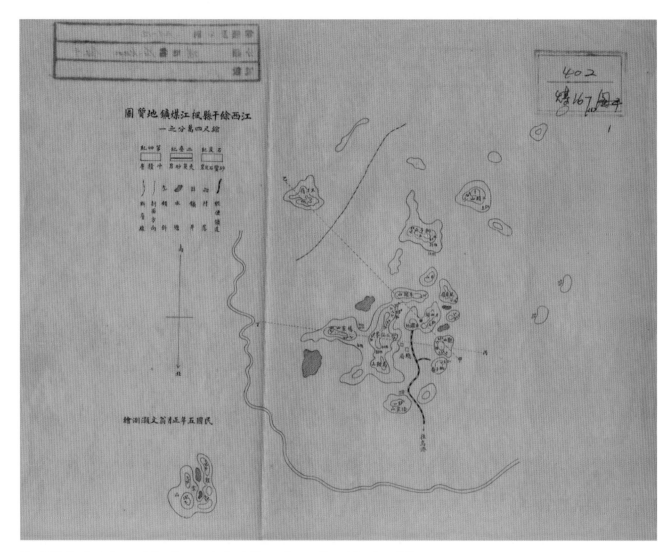

Fig. 2.10 Geological map of Fengjiang coal mine in Yugan County, Jiangxi Province [10]

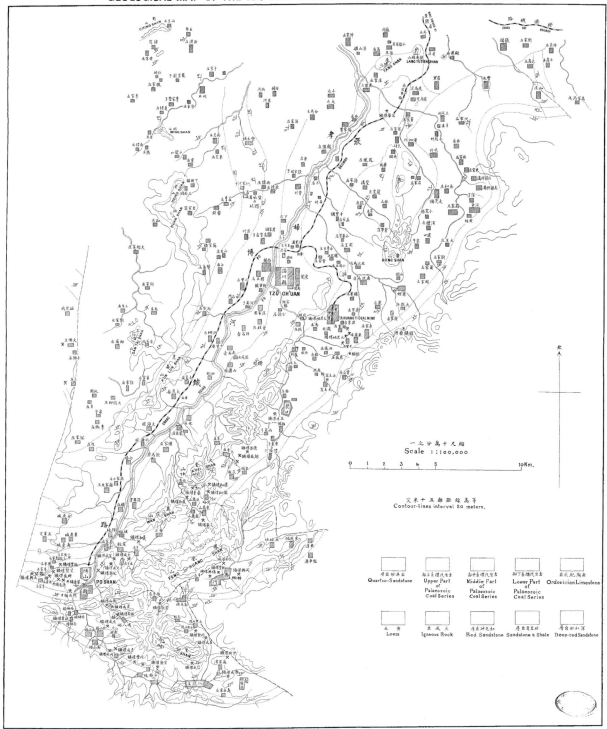

Fig. 2.11 Geological map of Boshan coalfield in Zichuan County, Shandong Province [11]

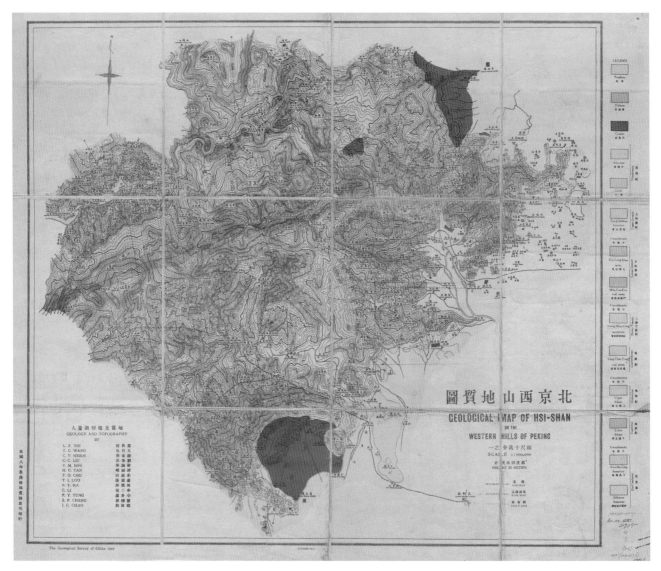

Fig. 2.12 Geological map of Mt. Xishan, Beijing [12]

This is the first geological map on a 1:100,000 scale that was independently surveyed and mapped by Chinese geologists. It was published in 1920 as the first supplementary issue of "Geological Special Report", the first regional geological monograph written by Chinese geological scientists (Fig. 2.12).

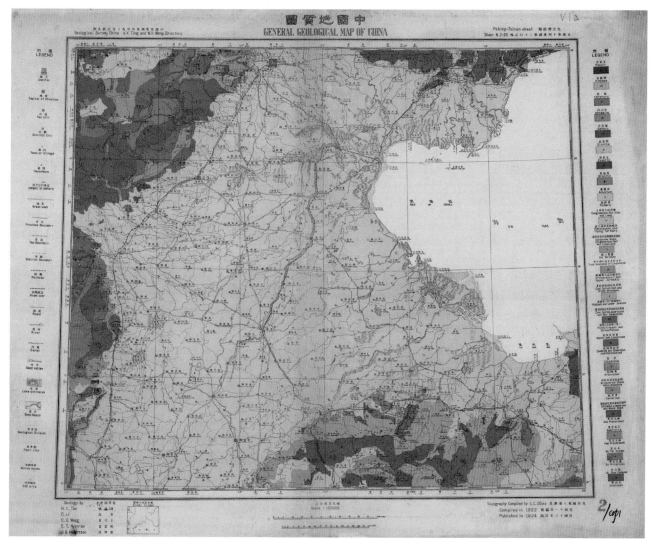

Fig. 2.13 Chinese geological map (1:1,000,000):Beijing-Jinan areas and brochure [13]

This is the first geological map of a large region with standard sheet division (1:1,000,000) compiled by Chinese geologists. One of three small-scale geological maps with standard sheet division, it was completed under the supervision of WenhaoWeng, the acting director of the China Geological Survey during 1921-1924, and of substantial strategic significance(collection of the National Geological Library of China)(Fig. 2.13).

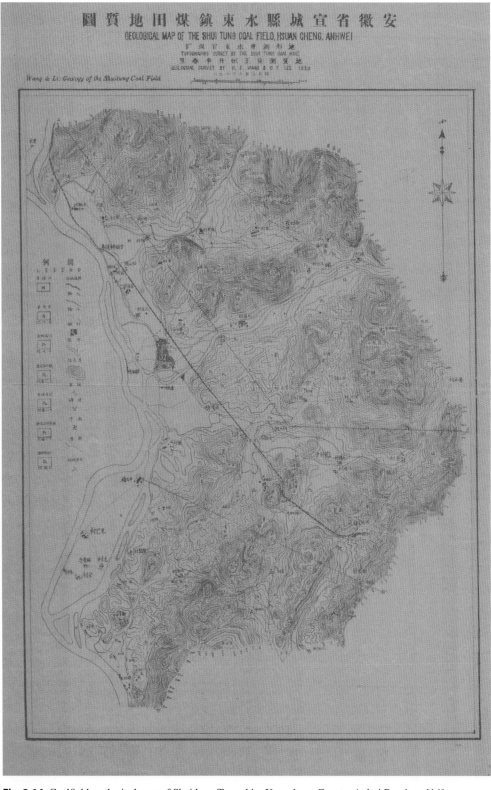

Fig. 2.14 Coalfield geological map of Shuidong Township, Xuancheng County, Anhui Province [14]

In this map, the contours, strata, and rock properties of a terrain in Anhui Province are depicted using single red lines. The lines are dense in the right part of the map but sparse in the left part and show the effect of relative concentration and partial sparseness, which generate an appealing contrast(Fig. 2.14).

This map depicts the distribution of lead, copper, gold, asbestos, sulfur, and pyrite in Xikang district (now the Yajiang area of Sichuan Province). The map is mainly drawn with delicate and smooth lines, which are mainly green contour lines, partially supplemented by red lines and blocks in blue, yellow, red, etc., with a neat and forceful calligraphy of regular script in small characters. These characteristics combine to lend the map an antique allure(Fig. 2.15).

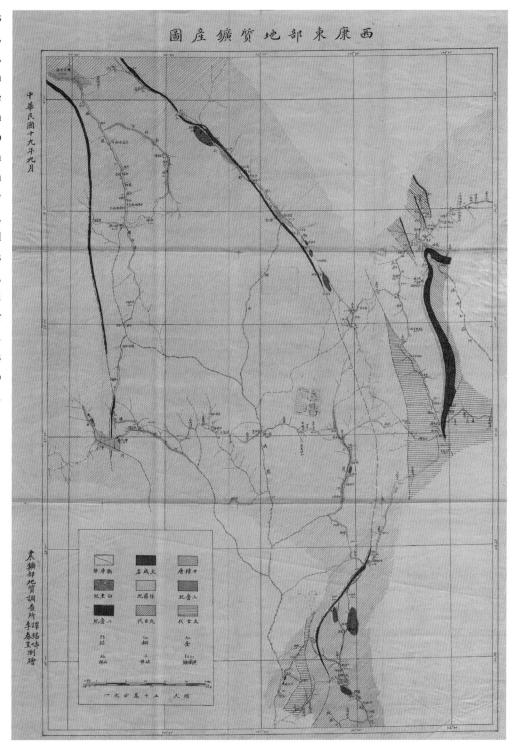

Fig. 2.15 Geological mineral map of eastern part of Xikang District [15]

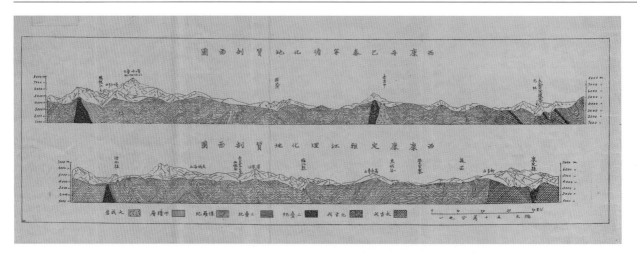

Fig. 2.16 Two geological maps of Danba, Taining, and Zhanhua Counties, Xikang District [16]

The lines on the maps are elegant, smooth, precise, and clean, and the colors are bright and distinct. The frames of the maps are uncluttered(Fig. 2.16).

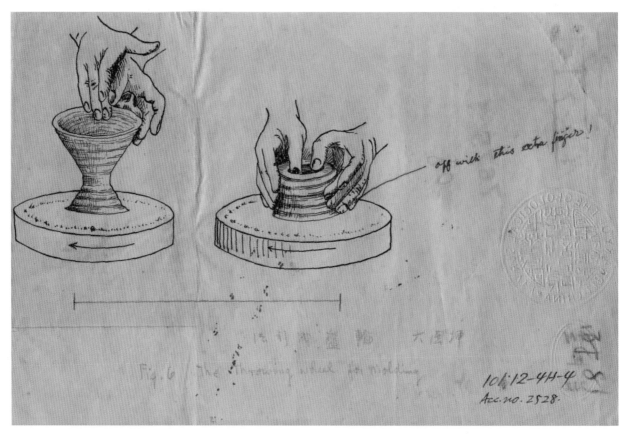

Fig. 2.17 Production method of potter's wheel [17]

This schematic diagram of the production method of a potter's wheelis rendered concisely with adequate detail. The simple light effects and indicators on the drawing make the production process easily understood (Fig. 2.17).

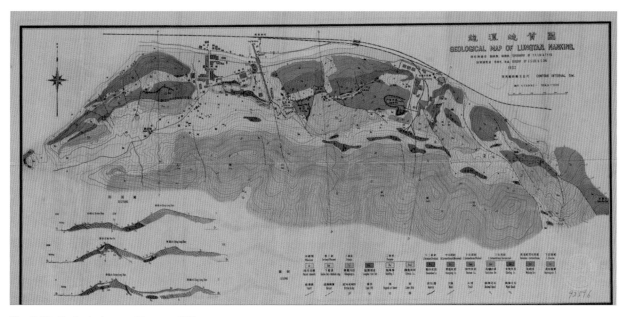

Fig. 2.18 Geological map of Longtan[18]

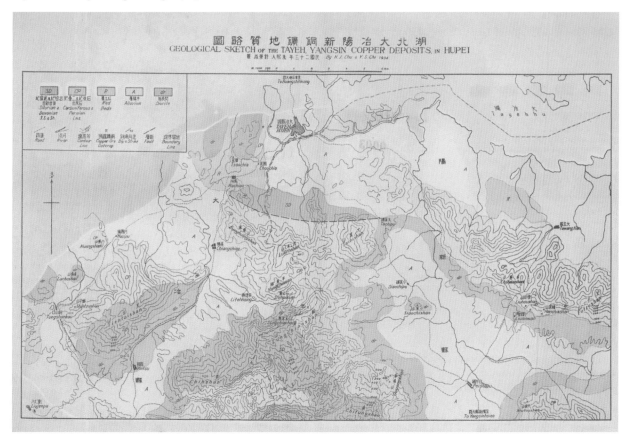

Fig. 2.19 Geological sketch of Yangxin copper mine, Daye, Hubei Province [19]

This sketch depicts the distribution of outcrops of copper and the formation of rock strata in Daye, Hubei Province(Fig. 2.19).

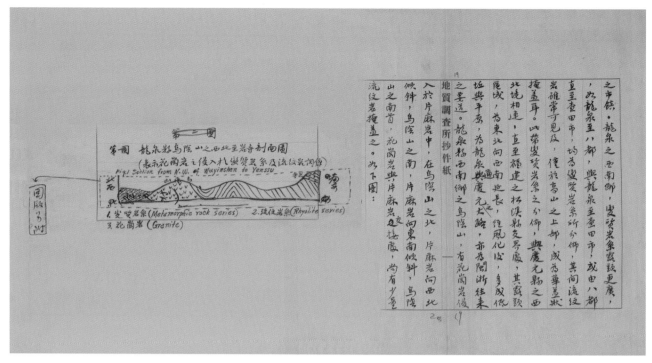

Fig. 2.20 Geological profile of the area from the northwest of Mt. Wuyin to Yansi, Longquan County [20]

References

1. Anonymous. Geological sketch map of Mt. Dongting, Wuxian County, Jiangsu Province. 1914. doi:https://doi.org/10.12063/data.A.2018.NGA0368.T1.1.1.

2. Ding Wenjiang. Geological map of eastern Yunnan. 1914. doi: https://doi.org/10.12063/data.A.2018.NGA7540.T1.4.1.

3. Ding Wenjiang. Generalised section through eastern Yunnan by V.K. Ting. 1914. doi:https://doi.org/10.12063/data.A.2018.NGA7540.T1.9.1.

4. Ding Wenjiang. Geological map of Dachang, Guangxi province. 1914. doi:https://doi.org/10.12063/data.A.2018.NGA7540.T1.21.1.

5. Ding Wenjiang. Geological map of coalfield of Yixian, Shandong province. 1916. doi:https://doi.org/10.12063/data.B.2018.NGA7540.T1.46.1.

6. Zhang Hongzhao. Geological map of iron ore deposit in Xibei Township, Fanchang County. 1915. doi: https://doi.org/10.12063/data.C.2018.NGA2091.T1.2.1.

7. Chen Shuping. Sketches of Ancient Creature's Fossils. 1915. doi: https://doi.org/ 10.12063/data.O.2018.NGA9404.T1.2.1.

8. WengWenhao. Histograms attached to report on BoyangjianMine, Leping County, Jiangxi Province. 1916. doi: https://doi.org/10.12063/data.A.2018.NGA0388.T1.1.1.

9. Liang Jin. Geology and mineral deposits map of Mt. Huitou (Part II). 1916. doi: https://doi.org/10.12063/data.C.2018.NGA0882.Z1.15.1.

10. WengWenhao. Geological map of Fengjiang Coal Mine in Yugan County, Jiangxi Province. 1916. doi: https://doi.org/10.12063/data.B.2018.NGA0402.T1.1.1.

11. Tan Xichou. Geological map of Boshan Coalfield in Zichuan County, Shandong Province. 1919.doi: https://doi.org/10.12063/data.B.2018.NGA0597.T1.1.1.

12. Ye Liangfu, Wang Zhuquan, XieJiarong, Liu Jichen, Xu Yuanmo, Tan Xichou, Zhu Tinghu, Lu Zuyin, Ma Bingduo, Li Jie, Tong Buying, Chen Shuping, Zhao Rujun. Geological map of Mt. Xishan, Beijing. 1919. doi: https://doi.org/10.12063/data.A.2018.NGA10541.T1.1.1.

13. Tan Xichou, Li Jie, Wang Zhuquan, Nystrom E.T., Andersson J.G. Chinese geological map (1:1,000,000):Beijing-Jinan areas and Brochure. Beijing, China Geological Survey, 1924.

14. Wang Hengsheng, Li Chunyu. Coalfield geological map of Shuidong Township, Xuancheng County, Anhui Province. 1929. doi: https://doi.org/ 10.12063/data.B.2018.NGA2753.T1.1.1.

15. Tan Xichou, Li Chunyu. Geological mineral map of eastern part of XikangDistrict . 1930. doi: https://doi.org/10.12063/data.C.2018.NGA2729.T1.1.1.

16. Tan Xichou, Li Chunyu. Two geological maps of Danba, Taining, and Zhanhua Counties, Xikang District. 1930. doi: https://doi.org/10.12063/data.A.2018.NGA2729.T1.3.1 .

17. HouDefeng. Production method of potter's wheel. 1931. doi: https://doi.org/10.12063/data.O.2018.NGA7675.T1.8.1.
18. Li Siguang, Zhu Sen. Geological map of Longtan. 1932. doi: https://doi.org/10.12063/data.O.2018.NGA4213.T1.1.1.
19. Zhu Xiren, JiRongsen. Geological sketch of Yangxin Copper Mine, Daye, Hubei Province. 1944. doi: https://doi.org/10.12063/data.C.2018.NGA3620.Z1.19.1.
20. Anonymous. Geological profile of the area from the northwest of Mt. Wuyin to Yansi, Longquan County. 1934. doi: https://doi.org/10.12063/data.O.2018.NGA1150.Z1.10.1.

Open Access This chapter is licensed under the terms of the Creative Commons Attribution 4.0 International License (http://creativecommons.org/licenses/by/4.0/), which permits use, sharing, adaptation, distribution and reproduction in any medium or format, as long as you give appropriate credit to the original author(s) and the source, provide a link to the Creative Commons licence and indicate if changes were made.

The images or other third party material in this chapter are included in the chapter's Creative Common slicence, unless indicated otherwise ina credit line to the material. If material is not included in the chapter's Creative Commons licence and your intended use is not permitted by statutory regulation or exceeds the permitted use, you will need to obtain permission directly from the copyright holder.

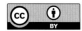

3 Exploration Period (1935-1953): The First Step Toward Standardization

Liqiong Jia, Xiaolei Li, Yuntao Shang, Xuezheng Gao, and Jie Meng

In 1936, Huang Jiqing published the *Problems of Colouring and Symbols of Geological Maps of China* and Nan Yanzong published *Discussion on the Usage of Igneous Rock Patterns on Geological Maps*. In 1937, Wang Bingzhang's published *Discussion on Symbols Colouring and Patterns of Geological Maps*. These made the first step toward "unification" and "standardization" in geological mapping in China.

At this stage, regional geological mapping began to have standard norms, with 1945 and 1948 Huang Jiqing et al.'s *1:3,000,000 Geological Maps of China* and a series of *Geological Maps of China (1:1,000,000)* as representatives. Through the compilation of these maps, breakthrough of zero geological map in mainland China has been achieved.

A series of geological maps during this period systematically summarized and reflected the achievements of geological survey and geological research in China in the first half of the twentieth century, provided important basic geological data for the planning and deployment of geological work in the First Five-Year Plan of the state, and laid a solid foundation for the future comprehensive geological mapping. In addition to the gradual standardization of geological maps, there are many vivid, interesting and exquisite hand-drawn drawings that show the beauty of nature from the perspective of geologists.

L. Jia (✉) · X. Li · Y. Shang · X. Gao · J. Meng
Development and Research Center of China Geological Survey
(National Geological Archives of China),
Xicheng District, Beijing, P.R. China

© The Author(s) 2019
C. Li et al. (eds.), *The Beauty of Geology: Art of Geology Mapping in China Over a Century*,
https://doi.org/10.1007/978-981-13-3786-4_3

Fig. 3.1 Microscopic diagram of pyrite from Mt. Liuhuan, Yingde, Guangdong Province [1]

This is a pencil drawing by early geologists of rock mineral specimens examined under a microscope. The detail demonstrates the professionalism and rigor of the scientists(Fig. 3.1).

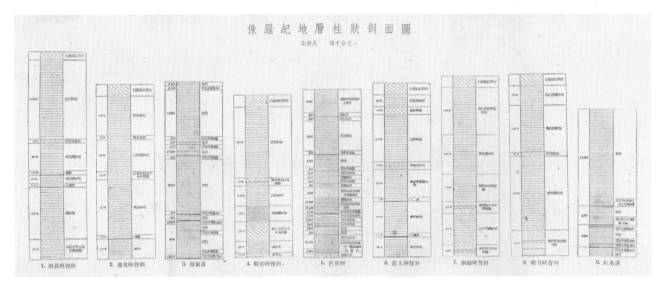

Fig. 3.2 Geologic column section of Jurassic stratum [2]

The mapclearly and concisely depicts geologic columnar profiles of Jurassic strata in Wenquanxia, Caijiagou, and elsewhere(Fig. 3.2).

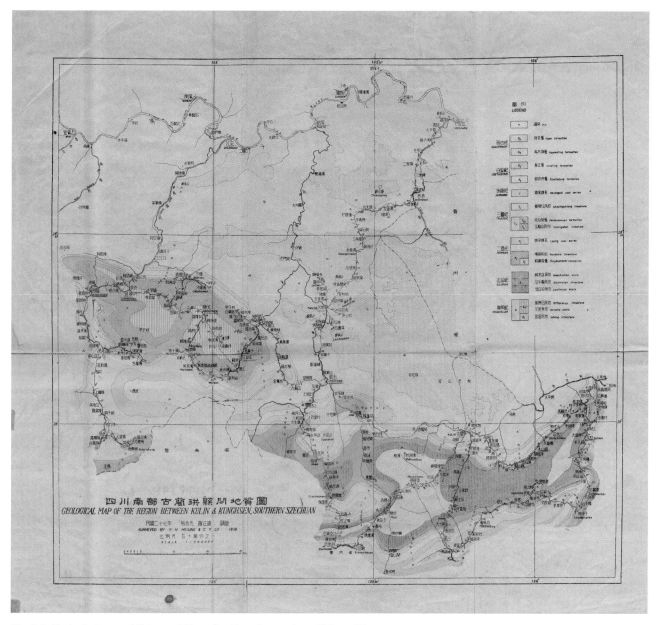

Fig. 3.3 Geological map of Gulan and Gongxian Counties, southern Sichuan [3]

In these multi-color regional geological maps, strata and rocks are distinguished using different colors and patterns, mostly in yellow and green. Place names are labeled, and both Chinese and English names are provided for the most important locations. The requirements of a standard geological map are generally satisfied: the map has detailed legend, frame, latitude and longitude lines, and latitudinal and longitudinal coordinates; only compass rose is missing(Fig. 3.3).

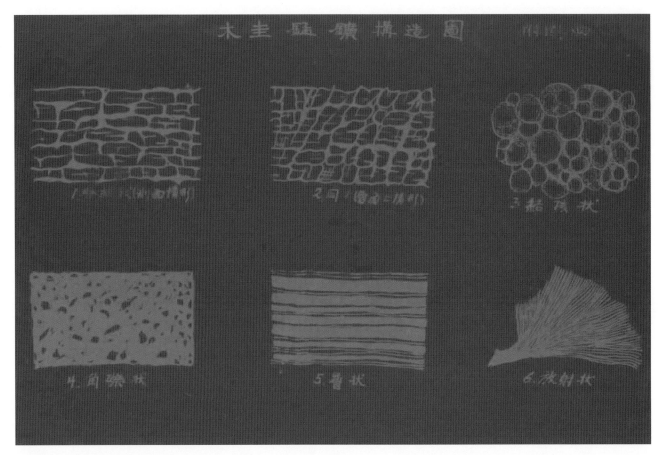

Fig. 3.4 Structure map of Mugui manganese mine [4]

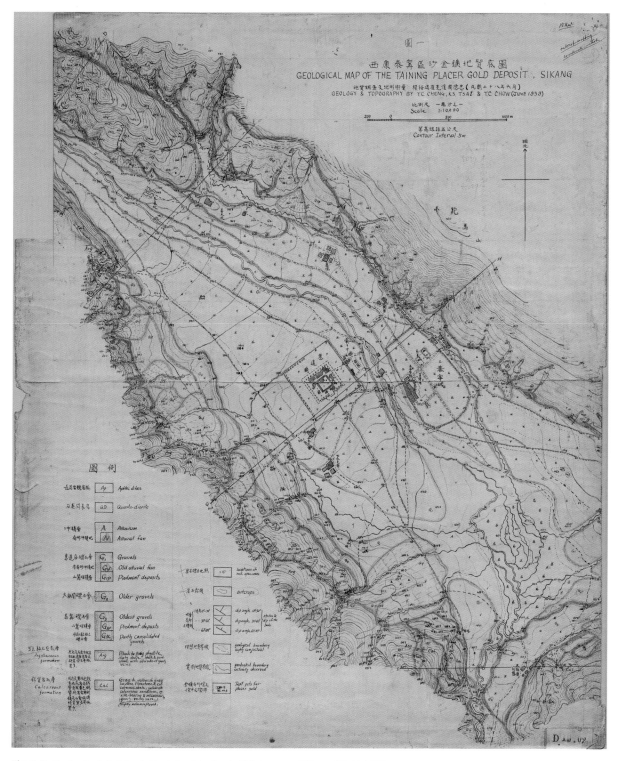

Fig. 3.5 Geological sketch of alluvial gold mine in Taining area, Xikang District [5]

The sketch adopts a diagonal composition and depicts the geology with lines of various thicknesses and colors. The yellowed paper is rich in old-fashioned charm(Fig. 3.5).

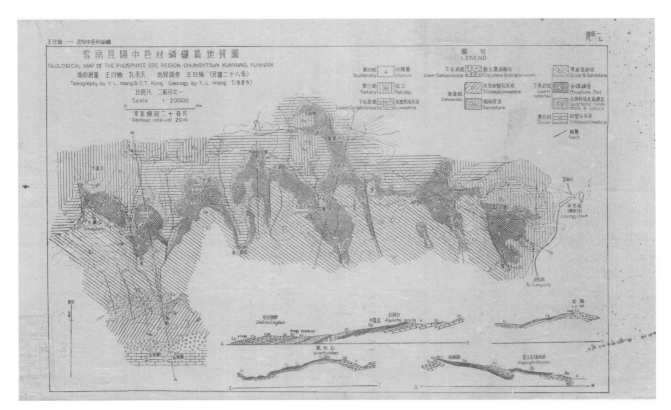

Fig. 3.6 Geological map of the phosphate mining area in Village Zhongyi, Kunyang, Yunnan Province [6]

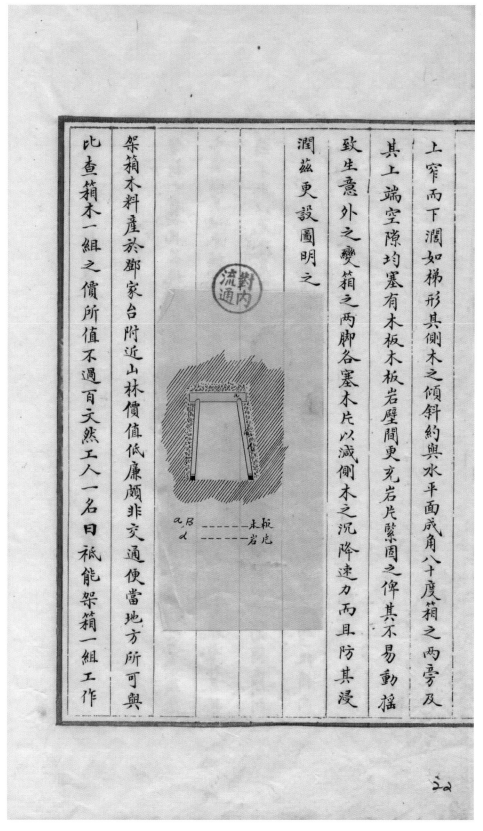

Fig. 3.7 Illustrations attached to special report on copper mines in Zhushan, Hubei Province [7]

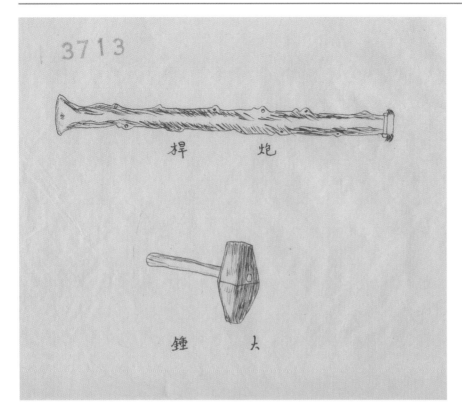

Fig. 3.8 Diagrams of tool and operations (1) [8]Source: Diagram of tool and operations (set of three-piece)

Fig. 3.9 Diagrams of tool and operations (2) [9]Source: Diagram of tool and operations (set of three-piece)

Fig. 3.10 Diagrams of tool and operations (3) [10]Source: Diagram of tool and operations (set of three- piece)

These generously illustrated diagrams vividly depict the tools and engineering operations of fieldwork duringthe early period of geological exploration(Figs. 3.8, 3.9, 3.10).

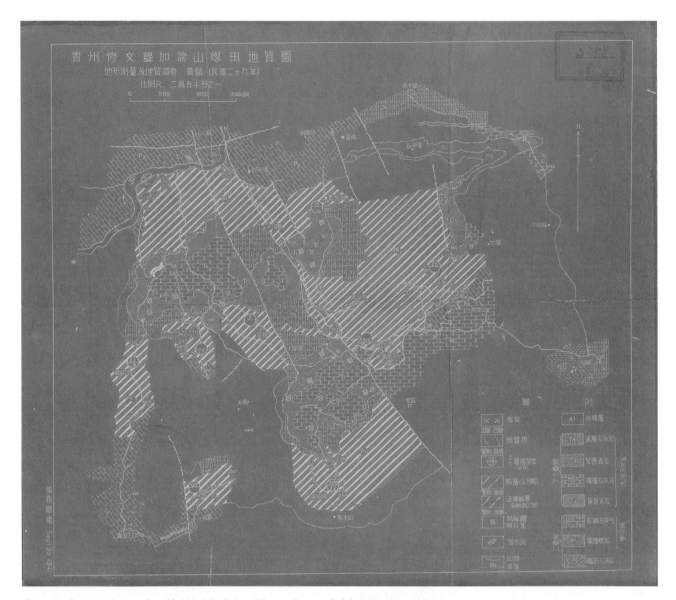

Fig. 3.11 Geological map of coalfield in Mt. Jiakua, Xiuwen County, Guizhou Province [11]

Blueprint of geological map with distinct lines and complete and orderly legends and patterns(Fig. 3.11).

3 Exploration Period (1935–1953):The First Step Toward Standardization

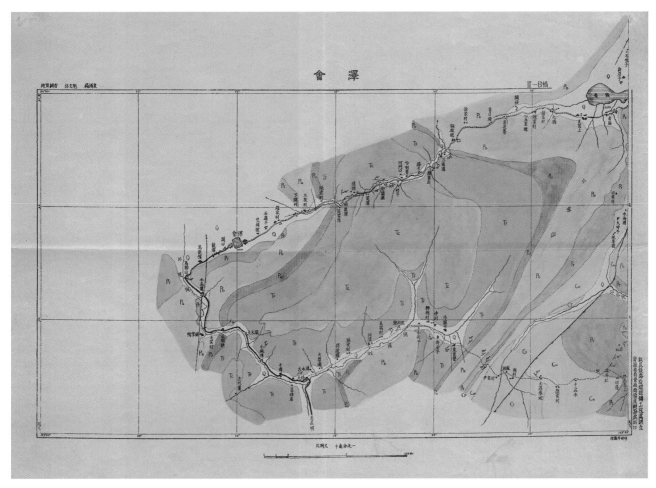

Fig. 3.12 Geological map of Huize[12]

Using ink and watercolors, the map depicts the strata and rock formations of the Huize section prospecting projects along the Xufu-Kunming Railway, with geographic grid and scale(Fig. 3.12).

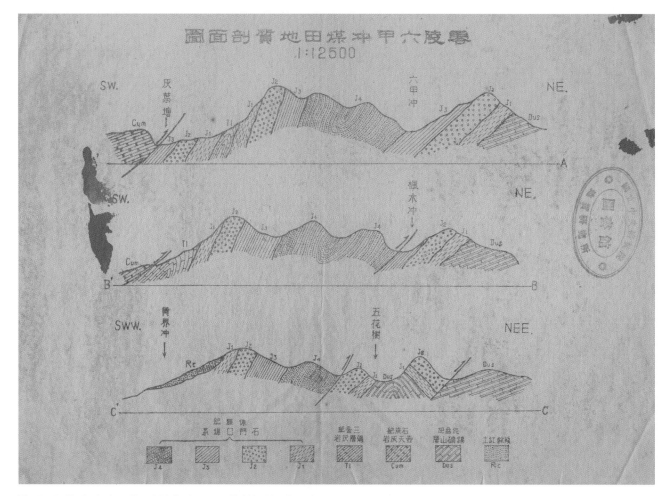

Fig. 3.13 Geological profile of Liujiachong coalfield in Lingling[13]

3 Exploration Period (1935–1953):The First Step Toward Standardization 35

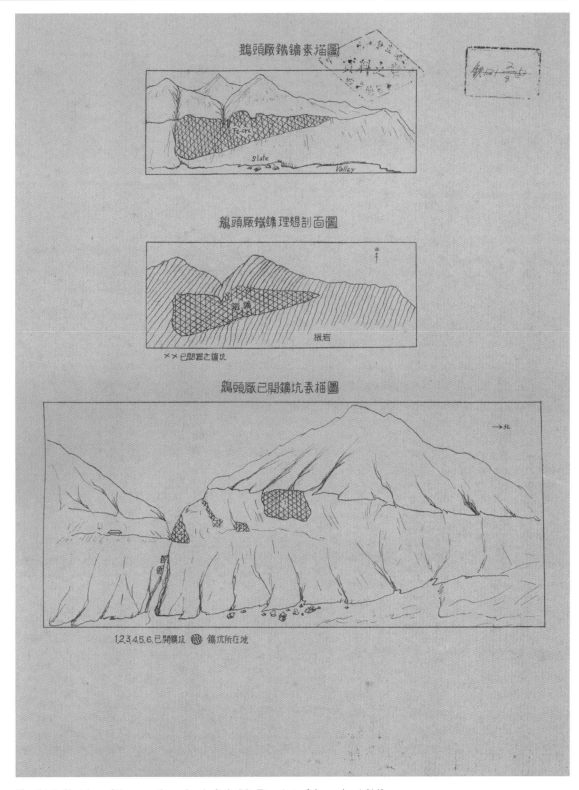

Fig. 3.14 Sketches of the operating mineshafts in Mt. Etou (set of three piece) [14]

Consists of three sketches drawn using single lines, with distinct layers and clear labels(Fig. 3.14).

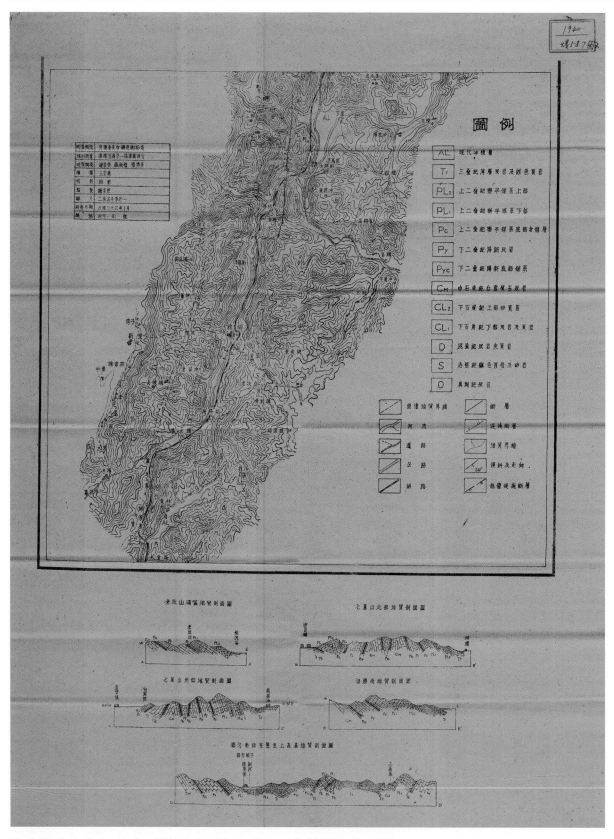

Fig. 3.15 Geological map of coalfields in the vicinity of Duyun, Guizhou Province [15]

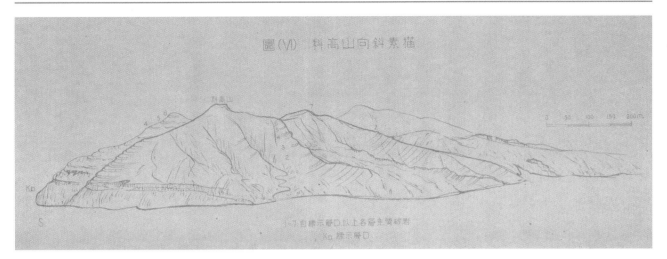

Fig. 3.16 Syncline sketch of Mt. Liaogao[16]

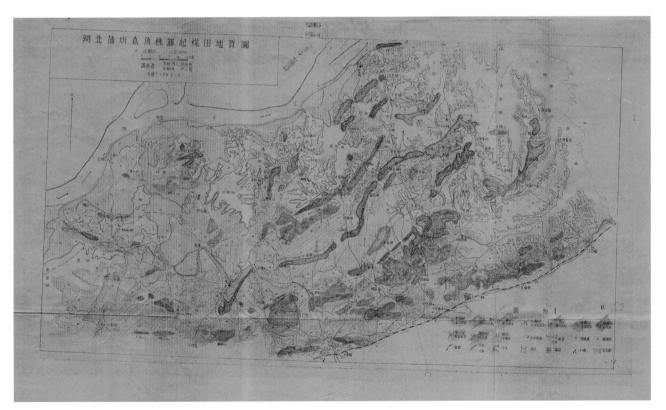

Fig. 3.17 Geological map of Jurassic coalfield in Puxin and Jiayu Counties, Hubei Province [17]

Antient paper with distinct linesand colored by crayon(Fig. 3.17).

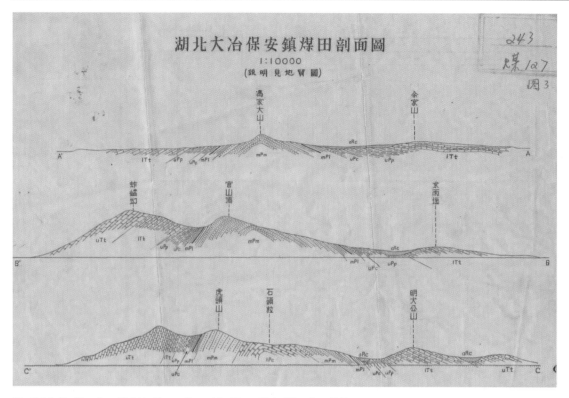

Fig. 3.18 Profile of coalfield in Baoan Township, Daye, Hubei Province[18]

The profile consists of three small sections, with detailed, well-rendered geological features at a glance(Fig. 3.18).

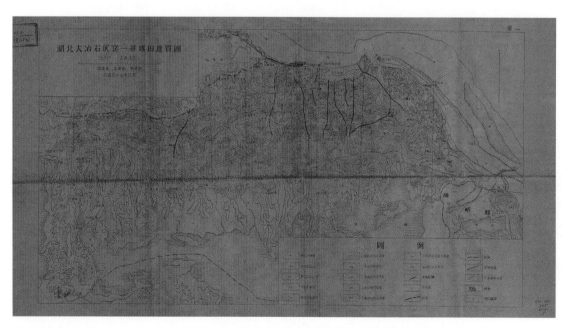

Fig. 3.19 Geological map of coalfields in the vicinity of Shihuiyao, Daye, Hubei Province [19]

The geological map is rich in content and cleanly drawn in single lines(Fig. 3.19).

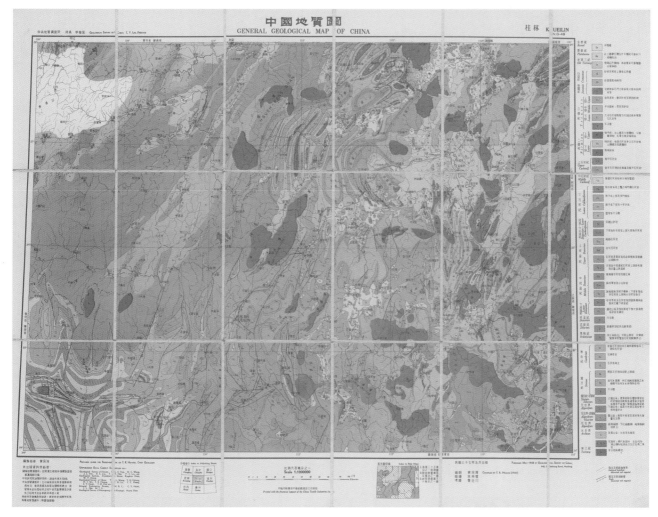

Fig. 3.20 China Geological Map (Guilin Sheet) [20]

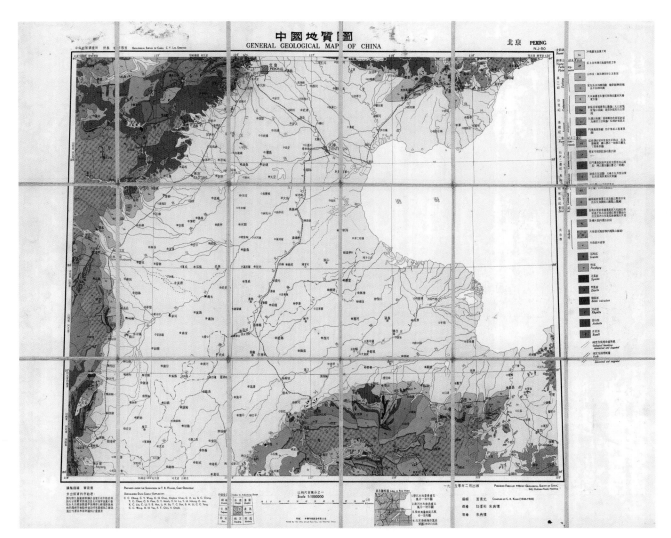

Fig. 3.21 China Geological Map (Beijing Sheet) [21]

From 1945 to 1948, under the leadership of Jiqing Huang, the director of the Regional Geological Research Office of the China Geological Survey, 14 sheets of geological map with standard sheet divisions on the scale of 1:1,000,000 was compiled. The map compilation systematically summarizes and depicts the achievements of the national geological survey in 1948 and represents the first national geological map of mainland China. The depicted sheet is bilingual (Chinese and English) with bright colors and was published based on a print from a fair drawing(Fig. 3.21).

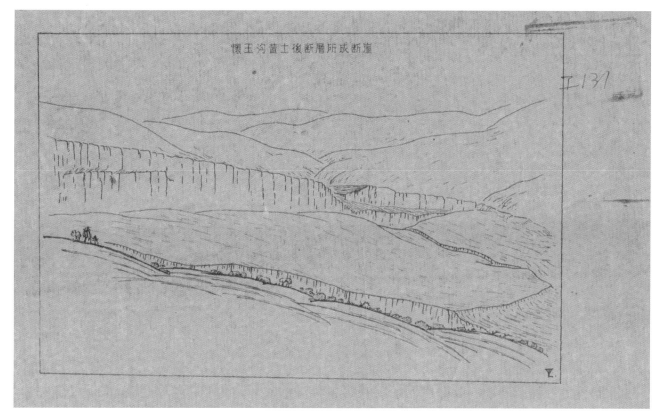

Fig. 3.22 Cliff formed from a fault after loessification in Huaiyugou [22]

A depiction of macroscopic geological bodies and an objective description of local geomorphology are integrated by the sketch artist. With its small number of strokes, the geological map has the appeal of a landscape painting (Fig. 3.22).

Fig. 3.23 Illustrations attaced to geological survey report of deposits in the vicinities of Xuanhua, Zhuolu and Yuxian[23]

3 Exploration Period (1935–1953):The First Step Toward Standardization

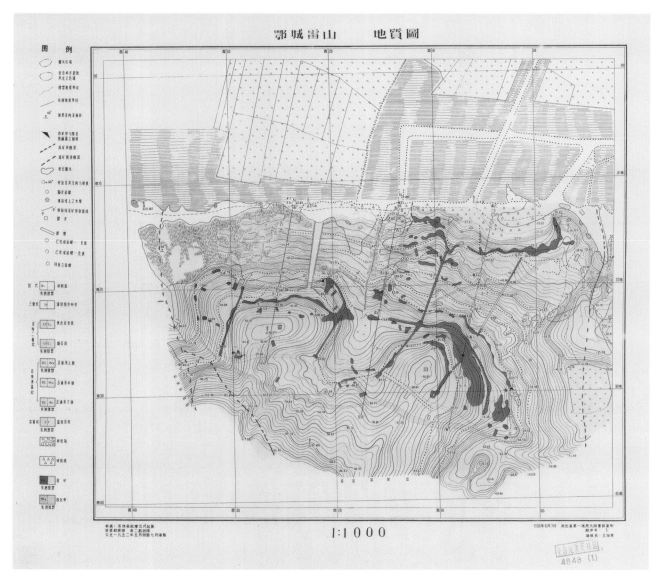

Fig. 3.24 Geological map of Mt. Leishan, Echeng[24]

The combination of clear, smooth single lines and coloring makes the map appealing and orderly. The map is in double-line frame, with latitudinal and longitudinal coordinates(Fig. 3.24).

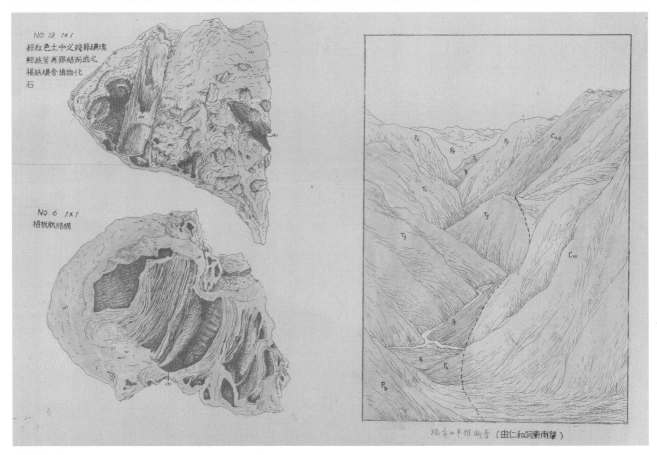

Fig. 3.25 Multiple diagrams of even faults at Mt. Guanyin [25]

These diagrams are drawn in crayon, mainly red and green. The clean lines objectively portray the local geomorphology while giving consideration to the art of sketching. The viewers feel as if they are in the midst of mountains rising on both sides(Fig. 3.25).

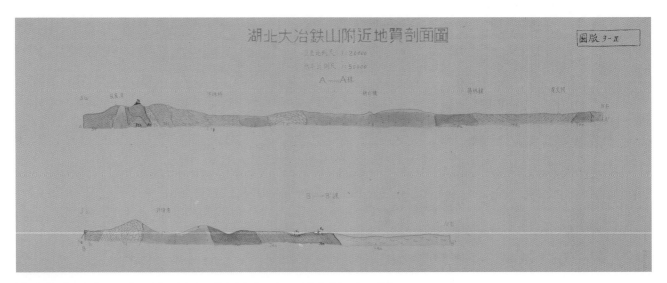

Fig. 3.26 Geological profile of the vicinity of Mt. Tieshan, Daye, Hubei Province [26]

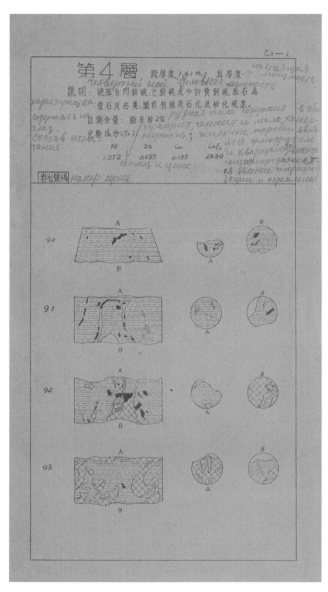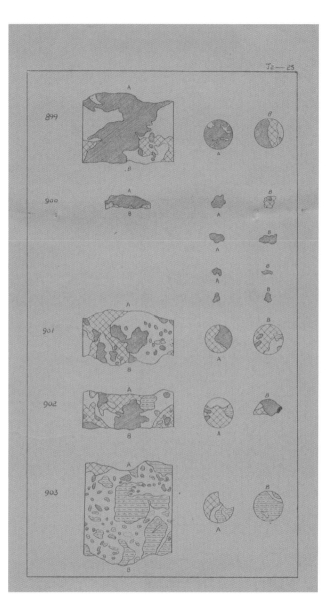

Fig. 3.27 The fourth layer sketch maps attached to report of geological exploration at Taolin, Hunan Province (sheet 1)[27]

Fig. 3.28 The fourth layer sketch maps attached to report of geological exploration at Taolin, Hunan Province (sheet 2) [28]

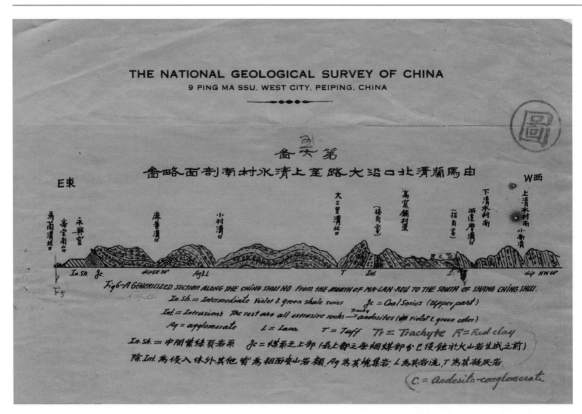

Fig. 3.29 Geological maps (profiles) of igneous rock and geological formations in the Zhaitang coalfield (Part II)[29]

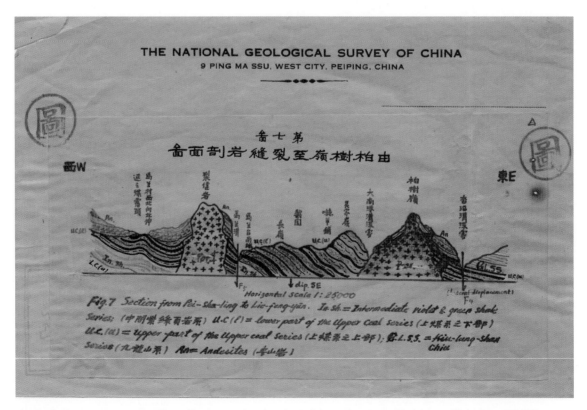

Fig. 3.30 Geological maps (profiles) of igneous rock and geological formations in the Zhaitang coalfield (Part IV) [30]

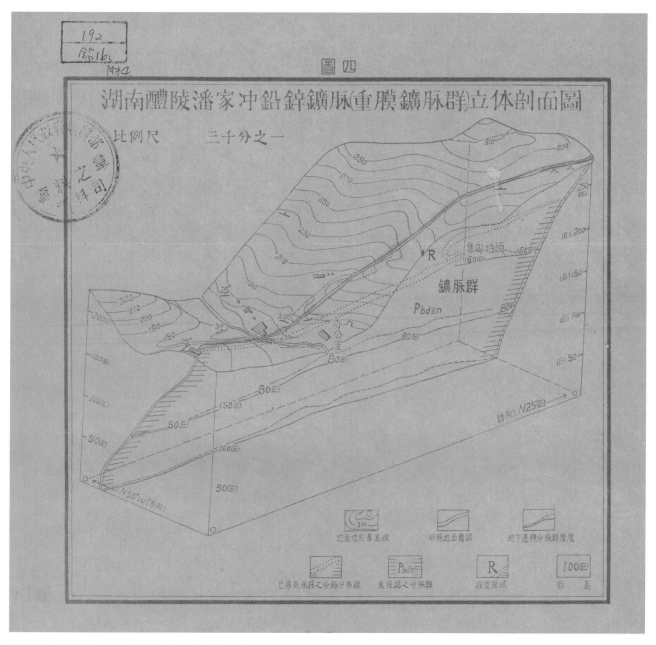

Fig. 3.31 Block-diagram of Panjiachong lead-zinc mine veins (sheeted zone) in Liling, Hunan Province [31]

References

1. Chen Guoda. Microscopic diagram of pyrite from Mt. Liuhuan, Yingde, Guangdong Province. 1935. doi:https://doi.org/10.12063/data.O.2018.NGA0539.J1.11.1.
2. Li Chunyu. Geologic column section of Jurassic stratum. 1938. doi:https://doi.org/10.12063/data.A.2018.NGA2909.T1.2.1.
3. XiongYongxian, Luo Zhengyuan. Geological map of Gulan Gongxian Counties, southern Sichuan. 1938. doi: https://doi.org/10.12063/data.A.2018.NGA3723.T1.1.1.
4. Gao Zhenxi, Wang Zhi. Structure map of Mugui Manganese Mine. 1938.doi:https://doi.org/10.12063/data.O.2018.NGA0114.T1.4.1.
5. Cheng Yuqi, Cui Kexin, Zhou Dezhong. Geological sketch of alluvial gold mine in Taining area, Xikang District. 1939. doi: https://doi.org/10.12063/data.C.2018.NGA0774.T1.1.1.
6. Wang Weilun. Geological map of the phosphate mining area in Village Zhongyi, Kunyang, Yunnan Province. 1939.doi: https://doi.org/10.12063/data.C.2018.NGA0657.T1.2.1.
7. Anonymous. Illustrations attached to special report on copper mines in Zhushan, Hubei Province.1940. doi: https://doi.org/10.12063/data.O.2018.NGA0907.Z1.22.1.
8. Cao Liying, Fan Jintai. Diagrams of tool and operations (1). 1940. doi: https://doi.org/10.12063/data.O.2018.NGA3713.Z1.29.1.
9. Cao Liying, Fan Jintai. Diagrams of tool and operations (2). 1940. doi:https://doi.org/10.12063/data.O.2018.NGA3713.Z1.30.1.
10. Cao Liying, Fan Jintai. Diagrams of tool and operations (3). 1940. doi:10.12063/data.O.2018.NGA3713.Z1.32.1.
11. Yi Huang. Geological Map of Coalfield in Mt. Jiakua, Xiuwen County, Guizhou Province. 1940. doi:https://doi.org/10.12063/data.B.2018.NGA0031.T1.5.1.
12. Li Shuming. Geological map of Huize. 1941. doi: https://doi.org/10.12063/data.A.2018.NGA1160.T1.10.1.
13. Anonymous. Geological profile of Liujiachong Coalfield in Lingling. 1942. doi:https://doi.org/10.12063/data.B.2018.NGA2699.T1.2.1.
14. Chen Guangyuan. Xu Hongyou. Sketches of the operating mineshafts in Mt. Etou (set of three piece). 1942. doi:https://doi.org/10.12063/data.O.2018.NGA9071.T1.4.1.
15. XieJiarong. Geological map of coalfields in the vicinity of Duyun, Guizhou Province. 1944. doi:https://doi.org/10.12063/data.A.2018.NGA1940.T1.3.1.
16. Hu Min, Song Hongnian. Syncline sketch of Mt. Liaogao. 1947. doi:https://doi.org/10.12063/data.O.2018.NGA0082.T1.11.1.
17. Gao Zhenxi, Chu Xuchun, Li Yuying, He Lixiang. Geological map of Jurassic coalfield in Puxin and Jiayu Counties, Hubei Province. 1947. doi:https://doi.org/10.12063/data.B.2018.NGA7662.T1.1.1.
18. Li Yuying, GaoZhenxi. Profile of coalfield in Baoan Township, Daye, Hubei Province. 1948.doi:https://doi.org/10.12063/data.B.2018.NGA0243.T1.3.1.
19. Gao Zhenxi, Li Yuying. Geological map of coalfields in the vicinity of Shihuiyao, Daye, Hubei Province. 1948. doi:https://doi.org/10.12063/data.B.2018.NGA0244.T1.1.1.
20. Huang Jiqing. China Geological Map (Guilin Sheet).1948. doi:https://doi.org/10.12063/data.A.2018.NGA12044.T1.5.1.
21. Huang Jiqing. China Geological Map (Beijing Sheet). 1948. doi:https://doi.org/10.12063/data.A.2018.NGA12044.T1.1.1.
22. Ye Lianjun, Wang Yu, Guan Shicong. Cliff formed from a fault after loessification in Huaiyugou. 1951. doi:https://doi.org/10.12063/data.O.2018.NGA2324.T1.35.1.
23. Bureau ofIndustry, the Chahar Provincial Government. Illustrations attaced to geological survey report of deposits in the vicinities of Xuanhua, Zhuolu and Yuxian. 1951. doi:https://doi.org/10.12063/data.O.2018.NGA5324.T1.2.1.
24. Wang Junying. Geological map of Mt. Leishan, Echeng. 1952. doi: https://doi.org/10.12063/data.A.2018.NGA4848.T1.3.1.
25. He Lixian. Multiple diagrams of even faults at Mt. Guanyin. 1952. doi: https://doi.org/10.12063/data.O.2018.NGA6693.T1.28.1.
26. Cheng Yuqi et al. Geological profile of the vicinity of Mt. Tieshan, Daye, Hubei Province. 1953. doi: https://doi.org/10.12063/data.A.2018.NGA6059.T1.4.1.
27. Zhang Yangcao. The fourth layer sketch maps attached to report of geological exploration at Taolin, Hunan Province (sheet 1). 1953. doi:https://doi.org/10.12063/data.O.2018.NGA6605.T2.266.1.
28. Zhang Yangcao. The fourth layer sketch maps attached to report of geological exploration at Taolin, Hunan Province (sheet 2). doi:https://doi.org/10.12063/data.O.2018.NGA6605.T2.300.1.
29. Wang Bingzhang. Geological maps (profiles) of igneous rock and geological formations in the Zhaitang Coalfield (Part II). doi:https://doi.org/10.12063/data.A.2018.NGA0357.T1.1.1.
30. Wang Bingzhang. Geological maps (profiles) of igneous rock and geological formations in the Zhaitang Coalfield (Part IV). doi: https://doi.org/10.12063/data.A.2018.NGA0357.T1.3.1.
31. Liao Shifan. Block-diagram of Panjiachong Lead-Zinc Mine Veins (sheeted zone) in Liling, Hunan Province. 1952. doi:https://doi.org/10.12063/data.C.2018.NGA5006.T1.4.1.

Open Access This chapter is licensed under the terms of the Creative Commons Attribution 4.0 International License (http://creativecommons.org/licenses/by/4.0/), which permits use, sharing, adaptation, distribution and reproduction in any medium or format, as long as you give appropriate credit to the original author(s) and the source, provide a link to the Creative Commons licence and indicate if changes were made.

The images or other third party material in this chapter are included in the chapter's Creative Common slicence, unless indicated otherwise ina credit line to the material. If material is not included in the chapter's Creative Commons licence and your intended use is not permitted by statutory regulation or exceeds the permitted use, you will need to obtain permission directly from the copyright holder.

Growth Period (1954-1994): Maps Displaying More Information and Printed in More Standard Way

Liqiong Jia, Zhaoyu Kong, Xuezheng Gao, Hui Guo, Xiaolei Li, and Chunzhen He

With the rapid development of national construction and geological work, from 1953 to 1956, the state set up four Sino-Soviet cooperation regional geological survey brigades (Xinjiang 13th geological brigade, Daxing'anling geological brigade, Qinling geological brigade and Nanling geological brigade). The *General Survey Notes*, compiled by Huang Jiqing and XieJiarong in 1954, put forward unified requirements for stratigraphic division, use of geological codes, various pattern symbols and color marks in field mapping, thus providing scientific basis for unified representation of large-scale geological maps in China. Through Sino-Soviet cooperation and the unremitting efforts of our geological predecessors, a new situation has been opened up for the regional geological survey and geological mapping in China.

During this period, China's geological mapping has developed rapidly, and at the same time it enjoys a lot of international reputation. For example, from 1973 to 1976, the *Geological Map of Asia(1:5,000,000)*, compiled by Li Tingdong, Li Chunyu and Wang Hongzhen, and *the Geological Map of the People's Republic of China(1:4,000,000)*, compiled by GengShufang, caused a great sensation when they participated in the 25th International Geological Congress exhibition, which was highly praised by foreign media.

China's geological mapping have developed to a more systematic and perfect stage. Geological map information is more rich and diverse, and the printing is more standardized. The relevant thematic studies are carried out simultaneously, such as agricultural ecological geology, environmental geology and tourism geology. The unified specific requirements of the representation method of geological maps, the shape, size, color and structure of symbols, as well as the schema and legend, create conditions for the rapid transmission of geological information and automatic mapping.

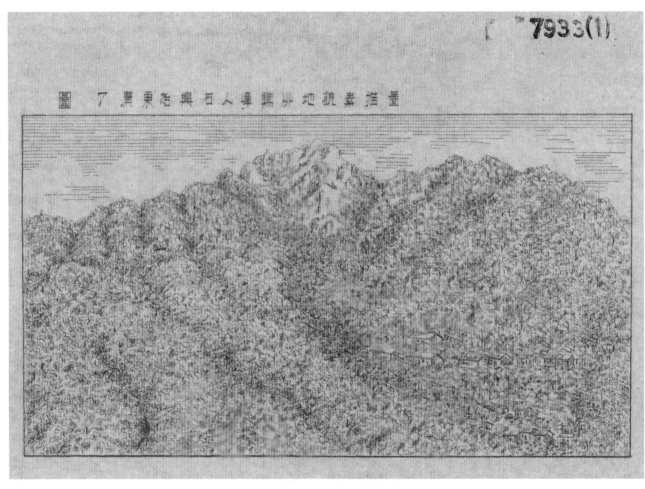

Fig. 4.1 Geomorphological sketch of Shirenfeng tungsten mine, Shixing, Guangdong Province, (Sheet 1) [1]

This monochromatic drawing has been meticulously done, with such fine attention to detail that even the houses behind the trees are accurately depicted. Mt. Shirenfeng is rendered using the simple wrinkled-texture method of traditional Chinese painting. Coupled with the clouds in background, this approach makes the picture both realistic and imaginative. The drawing's composition resembles that of a Tai Chi map, full of conflict and harmony(Fig. 4.1).

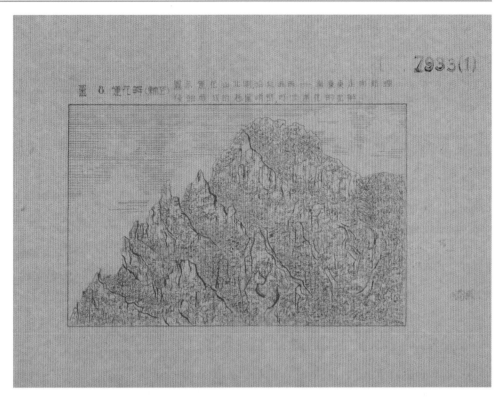

Fig. 4.2 Geomorphological sketch of Shirenfeng tungsten mine, Shixing, Guangdong, (Sheet 1) [2]

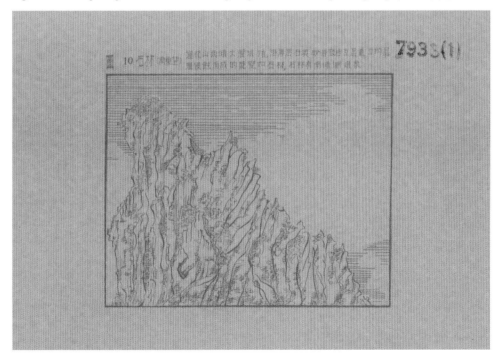

Fig. 4.3 Geomorphological sketch of Shirenfeng tungsten mine, Shixing, Guangdong, (Sheet 2) [3]

The measured layout and accurate rendition has high aesthetic quality. The vigorous lines seem dense enough to block the wind and recall the poetic thought that "The cloud wishes it were a bird" (Figs. 4.2 and 4.3).

Fig. 4.4 Diagram of a seam columnar section of Yaojie coal mine [4]

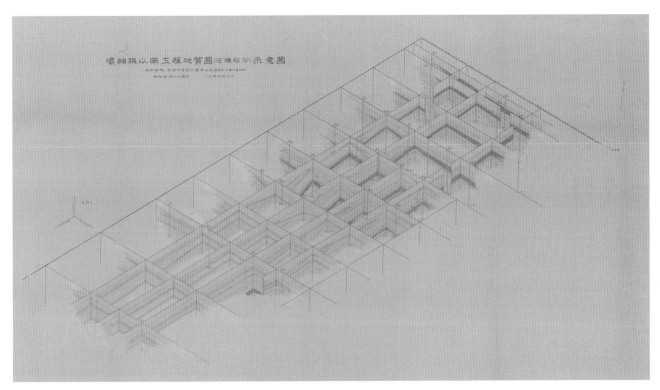

Fig. 4.5 Schematic diagram of the engineering geological map of areas south of the dam axis (river bed section) [5]

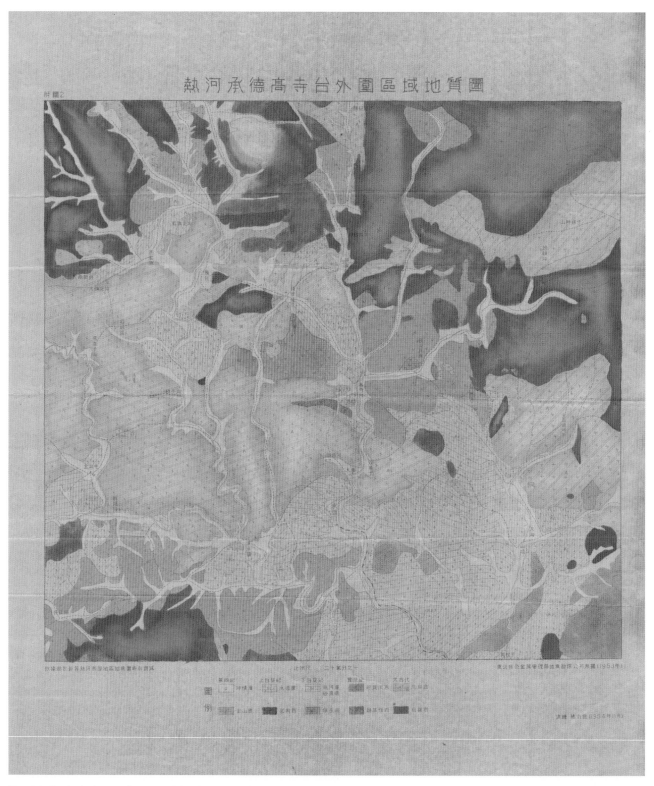

Fig. 4.6 Geological map of areas peripheral to Gaositai, Chengde, Rehe[6]

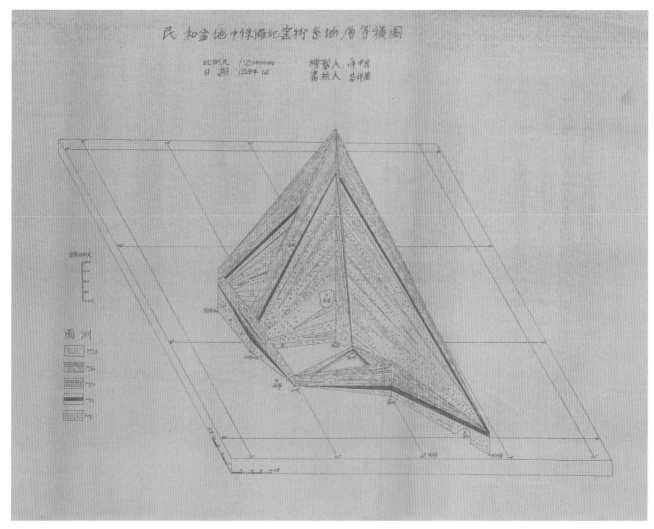

Fig. 4.7 Equal area chart of the middle Jurassic stratum of Yaojie coal mine in the Minhe Basin [7]

Overall, the diagram adopts a triangular format, with a strong sense of perspective. The diagram is vertical, orderly, and lively(Fig. 4.7).

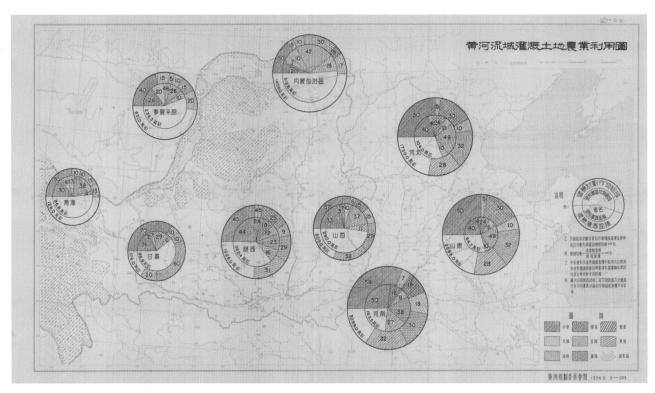

Fig. 4.8 Agricultural utilization map of irrigated land in the Yellow River Basin [8]

4 Growth Period (1954-1994):Maps Displaying More Information and Printed in More Standard Way

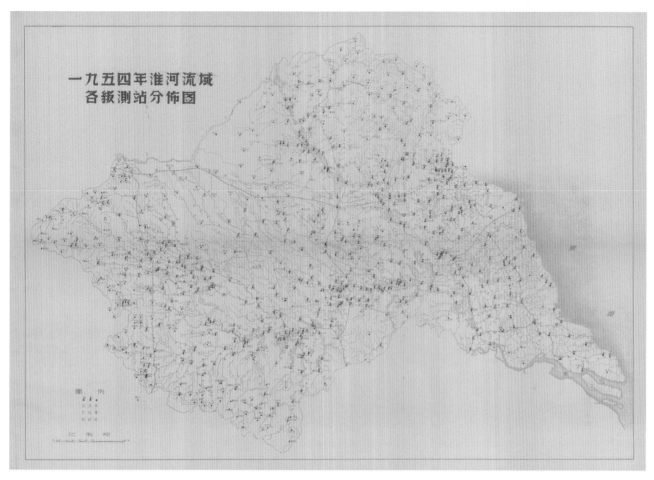

Fig. 4.9 Distribution of observation stations at various levels in the Huaihe River Basin in 1954 [9]

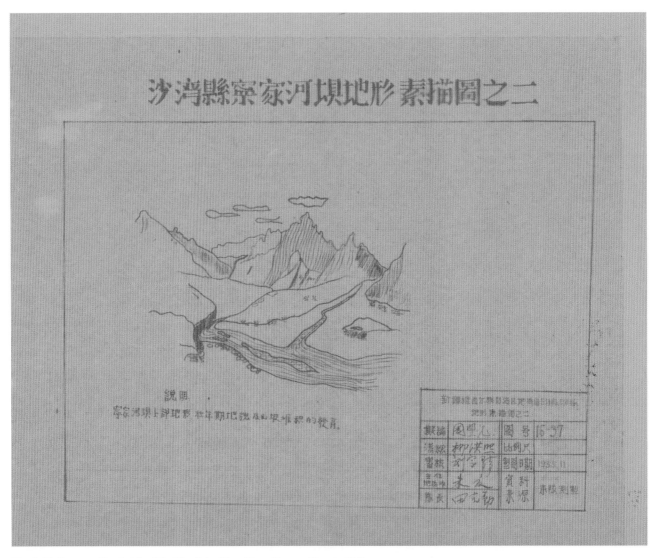

Fig. 4.10 Topographic sketch of the Ningjiahe River Dam, Shawan County [10]

The macroscopic geological terrain is depicted with fine, artistic lines, such that the sketch resembles an elegant landscape painting. Depicting the local landscape in an objective, detailed manner, the sketch adds dramatic effects through a background of towering mountains and streaming clouds(Fig. 4.10).

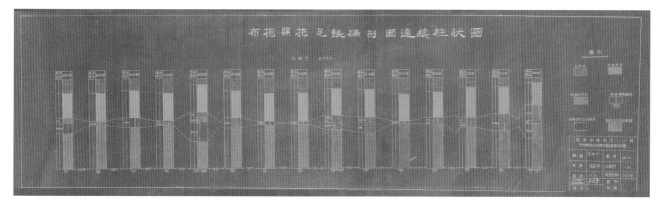

Fig. 4.11 Diagram of a continuous columnar section of Tuozu iron ore mine in Butuo County [11]

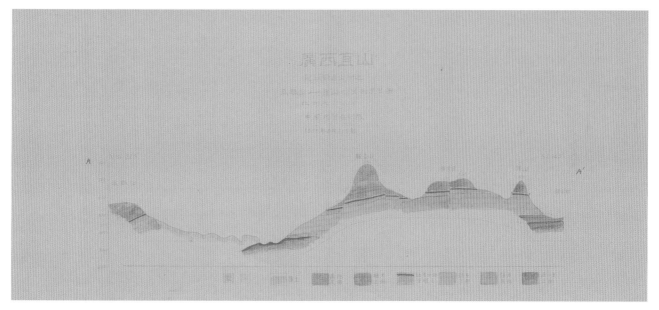

Fig. 4.12 Geological profile sketch of Mt. Guaran-Mt. Yinshan[12]

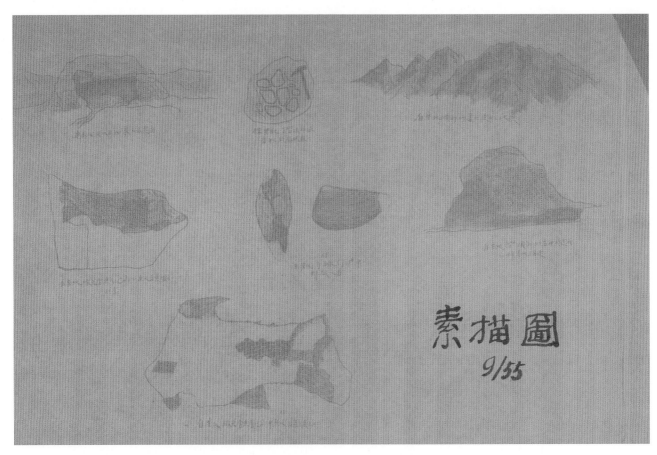

Fig. 4.13 Sketch attached to final geological report on Subashi in central Mt. Huoyan, the Turpan Basin [13]

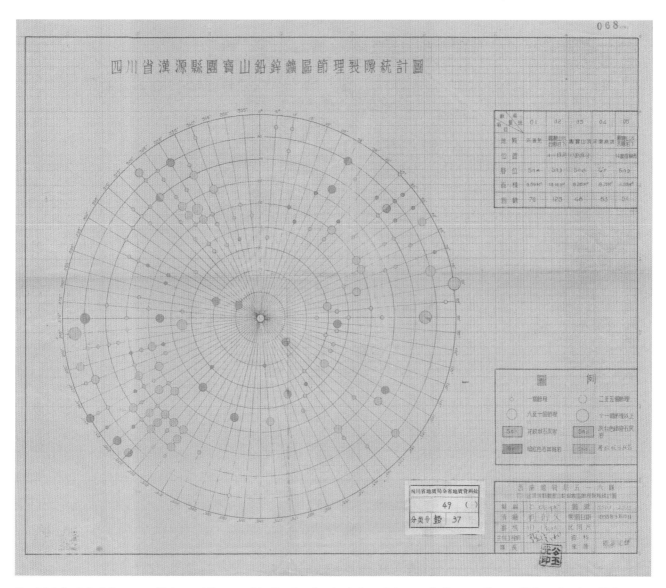

Fig. 4.14 Statistical diagrams of joints and fissures of the Tuanbaoshan lead-zinc mining area in Hanyuan County, Sichuan Province [14]

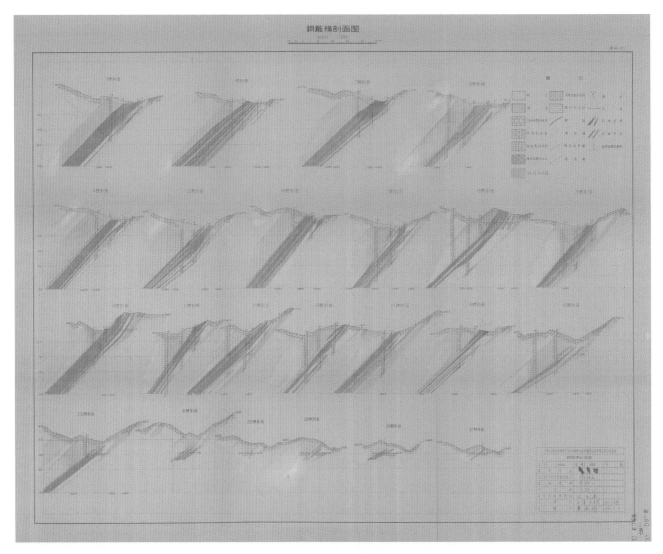

Fig. 4.15 Sectional diagram of a copper mine in the adjoining area of Yimen, Shuangbai, and Eshan Counties, Yunnan Province [15]

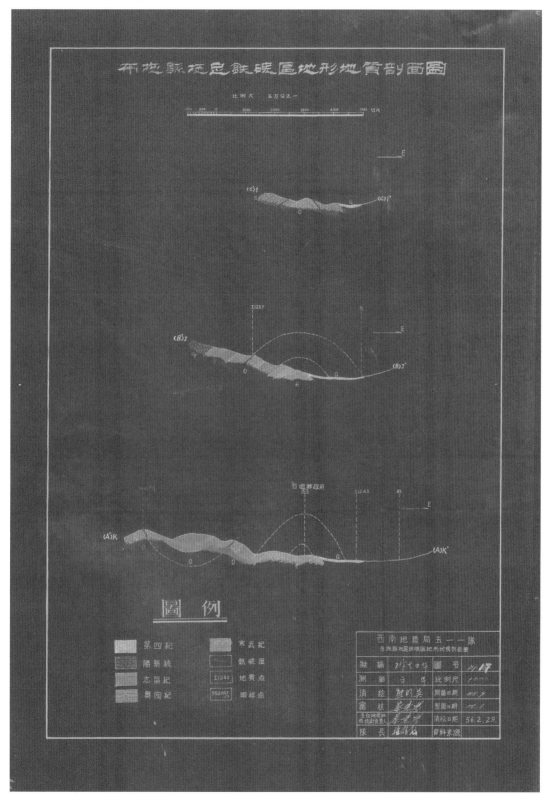

Fig. 4.16 Topographic and geological profile of Tuozu iron ore mine in Butuo County [16]

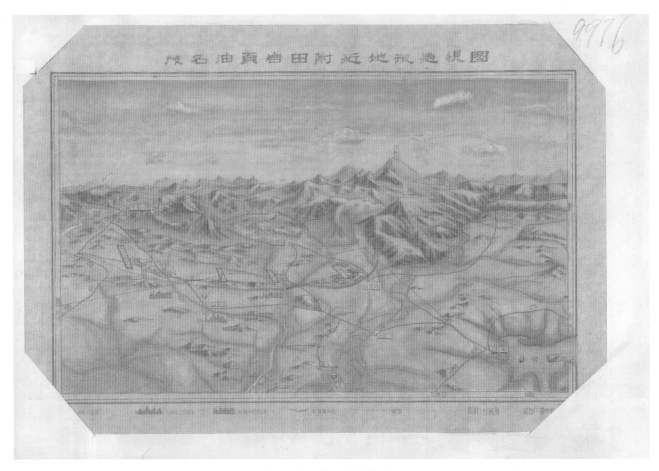

Fig. 4.17 Perspective view of the terrain in the vicinity of Maoming oil shale field [17]

The drawing is beautiful, with water in the foreground and mountains in the background in a movement from the dynamic to the static. The floating clouds add life to the quiet loftiness of the mountains while making the image more transparent, like a majestic perspective in oil painting. The drawing perfectly combines geology and aesthetics(Fig. 4.17).

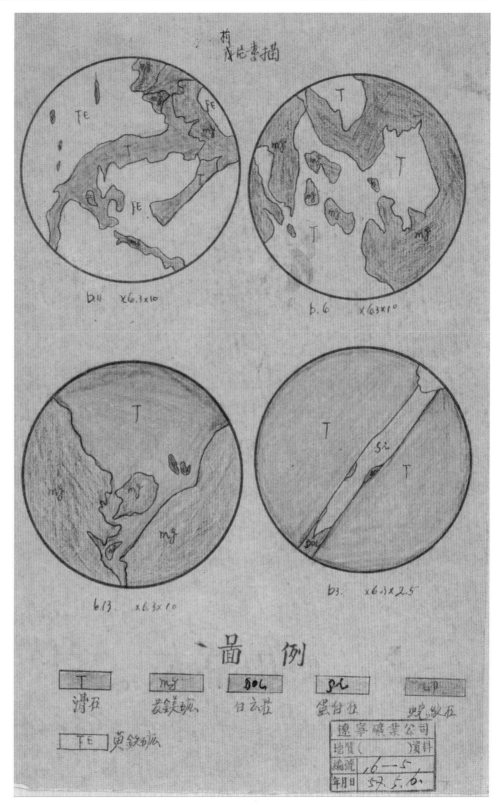

Fig. 4.18 Microscopic illustration attached to calculation table of a talc reserve in Fanjiapuzi[18]

The microscopic illustrations were drawn with colored pencils and are bright and succinct(Fig. 4.18).

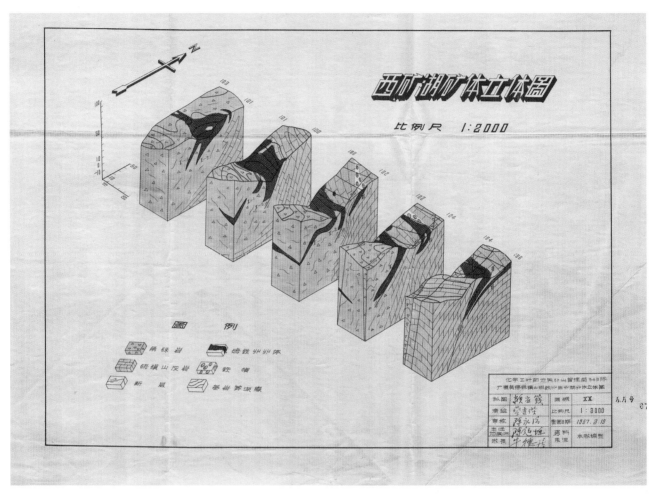

Fig. 4.19 Perspective diagram of ore bodies near West Lake [19]

The ore bodies in the diagram were drawn in orderly alignment and bright, contrasting colors. They are highlighted with geographical signs(Fig. 4.19).

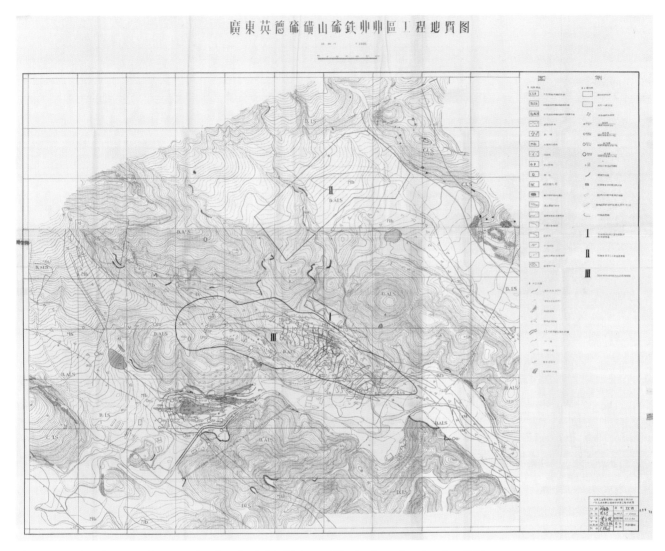

Fig. 4.20 Engineering geological map of pyrite mine in Mt. Liuhuang, Yingde, Guangdong Province [20]

The diagram is drawn in complex but clear lines combined with watercolor blocks and represents an engineering geological chart of a mining area in Guangdong Province(Fig. 4.20).

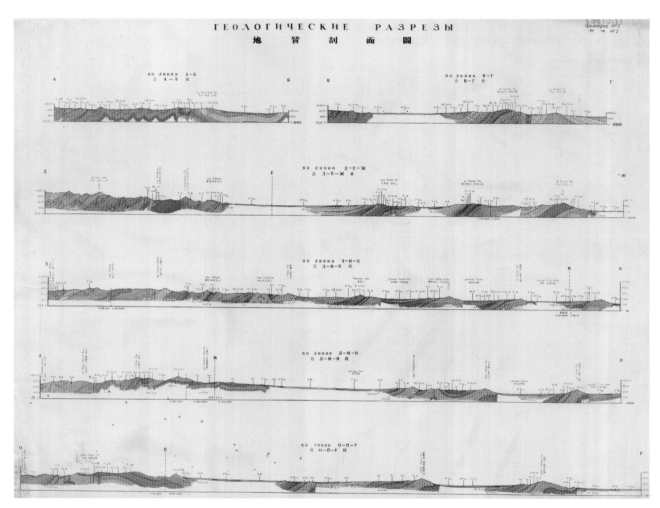

Fig. 4.21 Series of geological maps of the Kashi-Akesu region of Southern Mt. Tianshan, Xinjiang(1) [21] (Source: Part of the series to geological map of the Kashi-Akesu region of Southern Mt. Tianshan, Xinjiang.)

The creation of the 13th Sino-Soviet Geological Cooperation Brigade of Xinjiang in 1953 opened a new chapter in China's regional geological survey activity. The geological maps produced during this period are mostly bilingual in Chinese and Russian (Figs. 4.21 and 4.22).

Fig. 4.22 Series of geological maps of the Kashi-Akesu region of Southern Mt. Tianshan, Xinjiang(2) [22] (Source: Part of the series to geological map of the Kashi-Akesu region of Southern Mt. Tianshan, Xinjiang.)

Fig. 4.23 Schematic drilling diagram [23]

This diagram describes the core preservation in solid figure (Fig. 4.23).

Lines and gouache coloring were used in the diagram, making it orderly and elegant. There is a clearly drawn legend(Fig. 4.24).

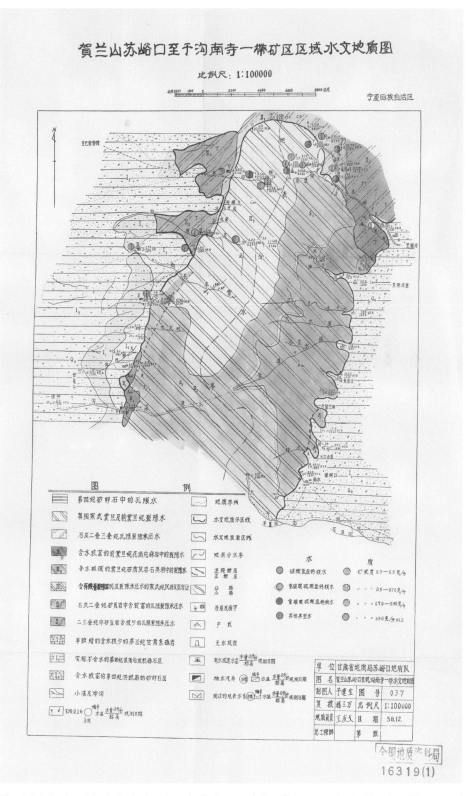

Fig. 4.24 Regional hydrological and geological map of the mining areas in the Suyukou, Yugou, and Nansi vicinities of Mt. Helan Mountain [24]

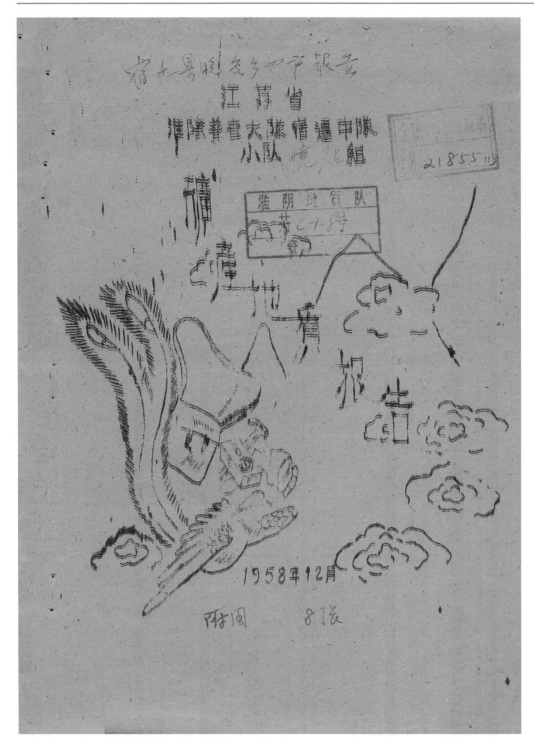

Fig. 4.25 Mineral geology report (cover) [25]

In contrast to the seriousness and simplicity of other report covers, this cover is decorated with a variety of imagery, such as a phoenix and auspicious clouds. The appealing effect is one of goodwill and suggests the creative enthusiasm of hard-working geologists(Fig. 4.25).

Fig. 4.26 Cover of the report on mineral exploration in Liancheng County [26]

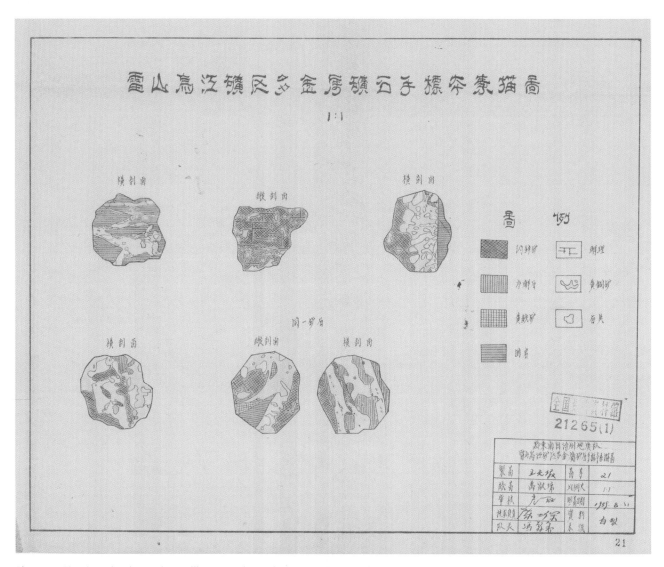

Fig. 4.27 Sketches of various polymetallic ore specimens from the Wujiang mining area of Leishan[27]

4 Growth Period (1954-1994):Maps Displaying More Information and Printed in More Standard Way

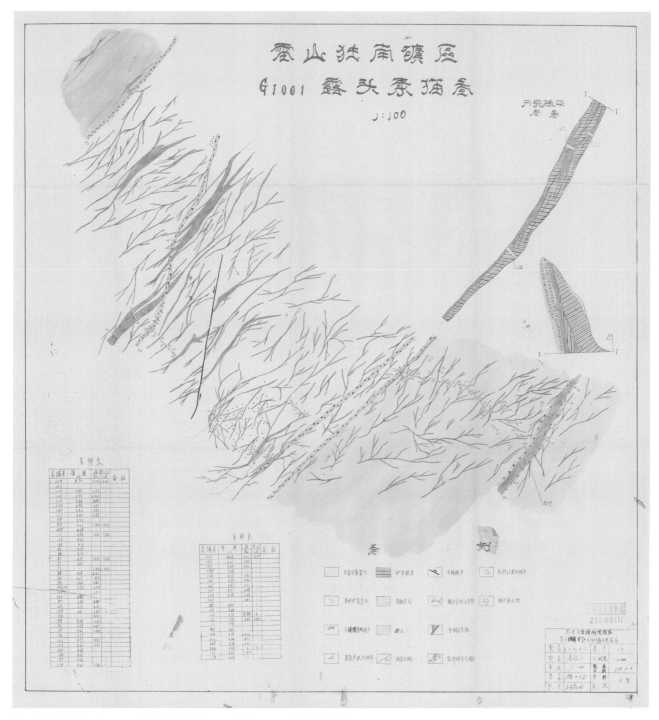

Fig. 4.28 Sketch of outcrop G1001 of the Dunanmining area of Leishan[28]

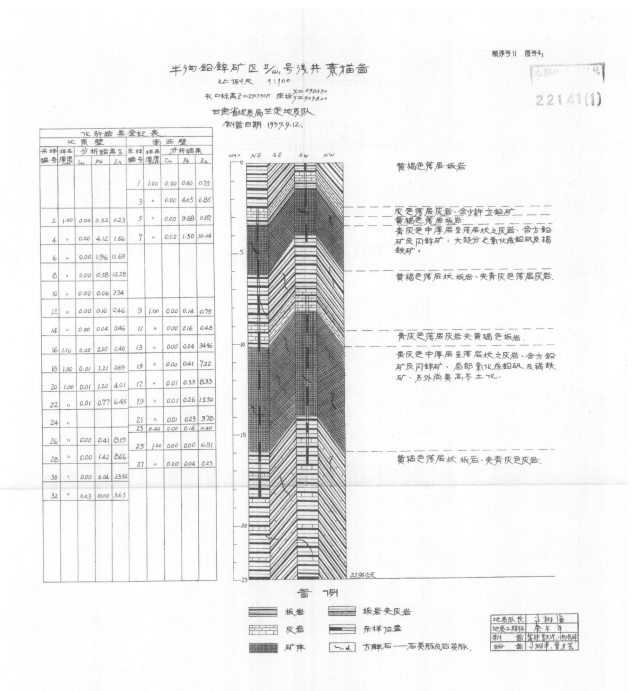

Fig. 4.29 Sketch of shallow well II/E1 of the lead-zinc mining area of Bangou[29]

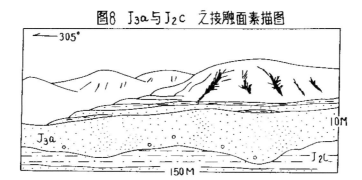

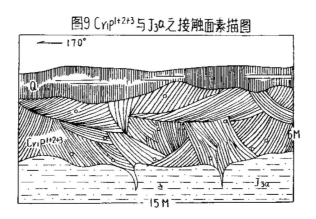

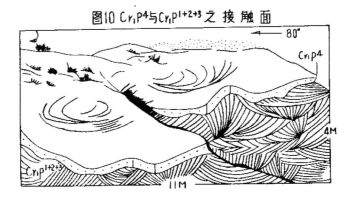

Fig. 4.30 Sketches of the interface of J_3a and J_2c, among others [30]

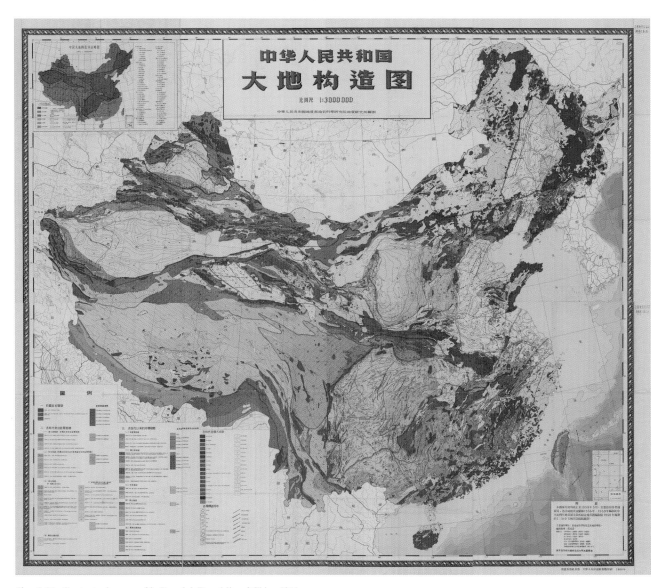

Fig. 4.31 Geotectonic map of the People's Republic of China [31]

This is China's first tectonic map on the scale of 1:3,000,000. The map had a profound impact at home and abroad and was widely recognized by geoscientists as an epoch-making and canonic achievement in the history of Asian tectonic studies(Fig. 4.31).

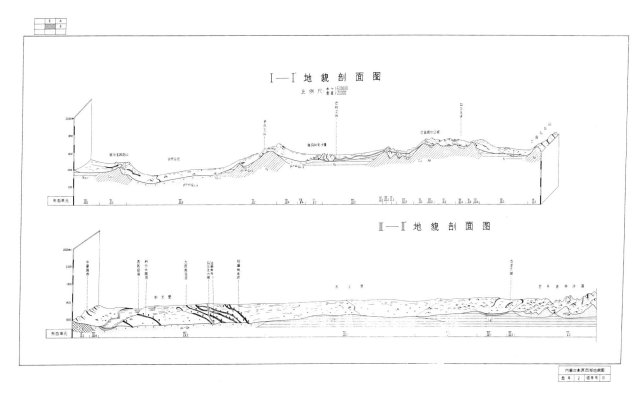

Fig. 4.32 Geomorphological map of the western Inner Mongolia Plateau (I-I',II-II' geomorphology sections) [32]

The monochromatic map is rich in content, with clear geological signs and depicting diverse terrain(Fig. 4.32).

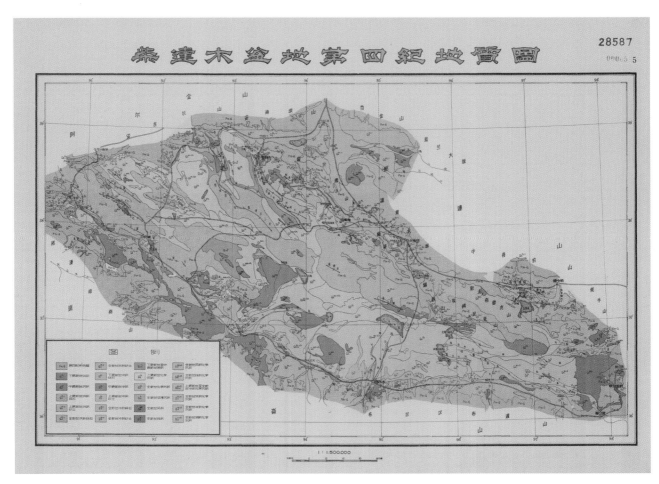

Fig. 4.33 Quaternary geological map of the Qaidam Basin [33]

The multi-color quaternary geological map is primarily rendered in yellow and green, with a double-line frame and a latitudinal and longitudinal grid. The colors are harmonious, while the content of the map is rich (Fig. 4.33).

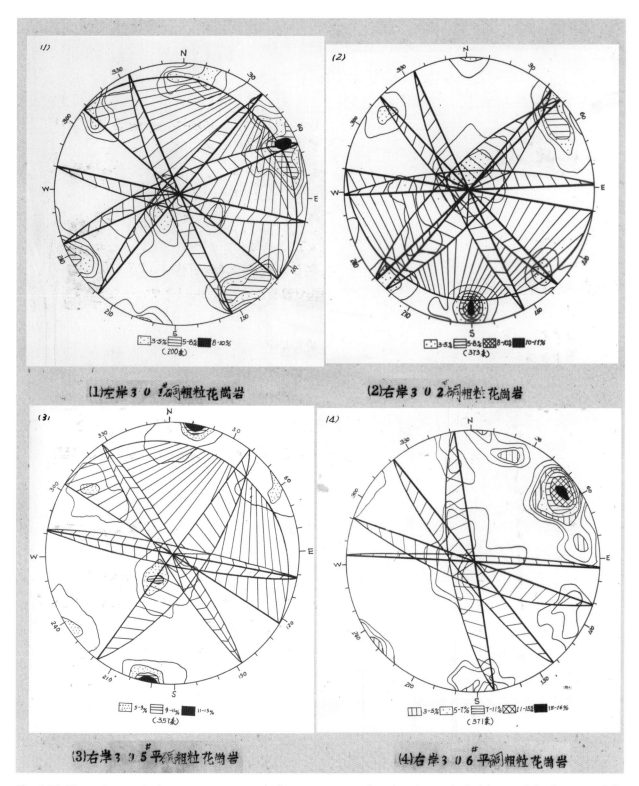

Fig. 4.34 Illustration attached to report on a tectonic fracture system and engineering geological issues of the dam area of the Xinfengjiang River [34]

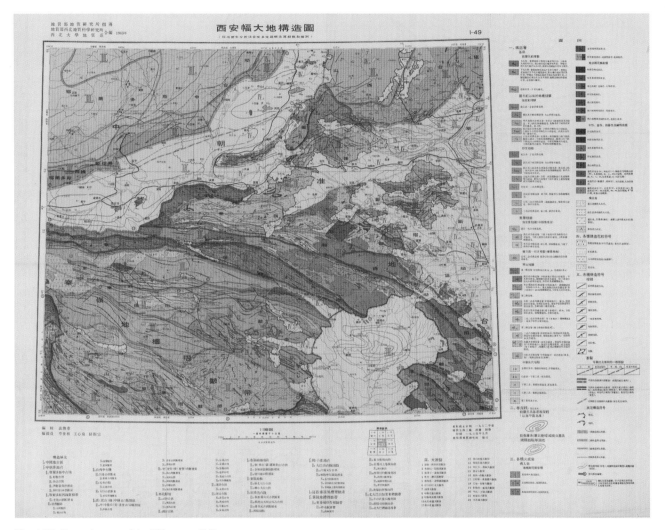

Fig. 4.35 Tectonic map of the Xi'an area [35]

This tectonic map with internal sheet division depicts complex content with bright and contrasting colors. It was published as a print from a fair drawing(Fig. 4.35).

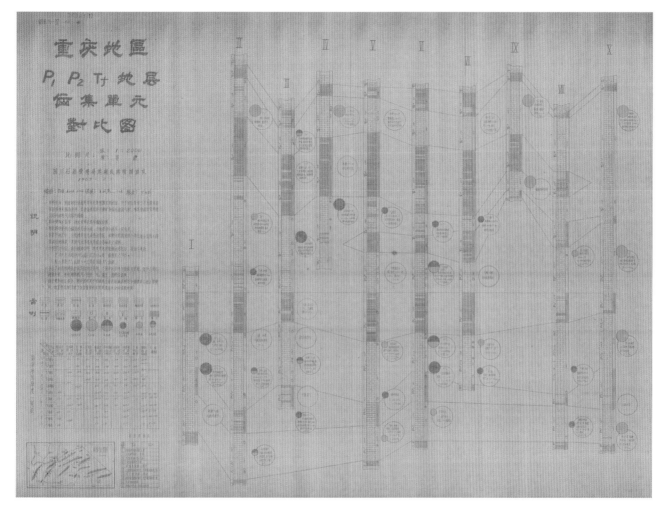

Fig. 4.36 Comparison of reservoir units of Strata P_1, P_2, and T_f in the Chongqing area [36]

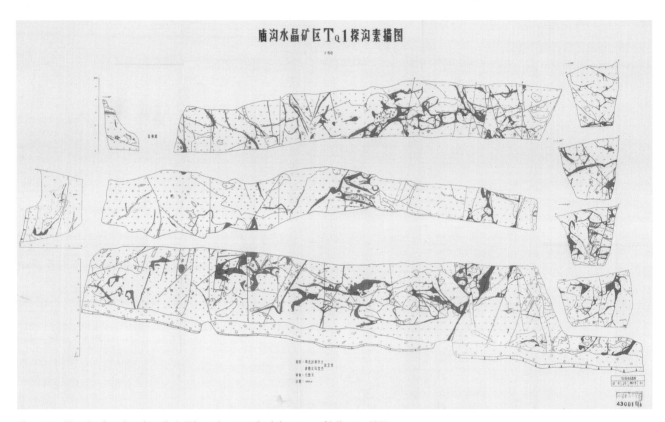

Fig. 4.37 Sketch of exploration ditch TQ$_1$ at the crystal mining area of Miaogou[37]

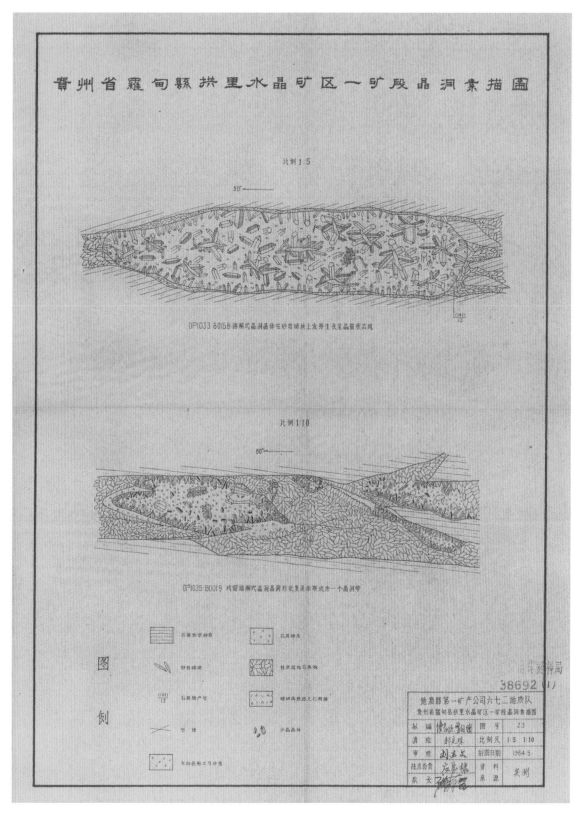

Fig. 4.38 Sketch of a geode in a mine block of the Gongli Crystal mining area, Luodian County, Guizhou Province [38]

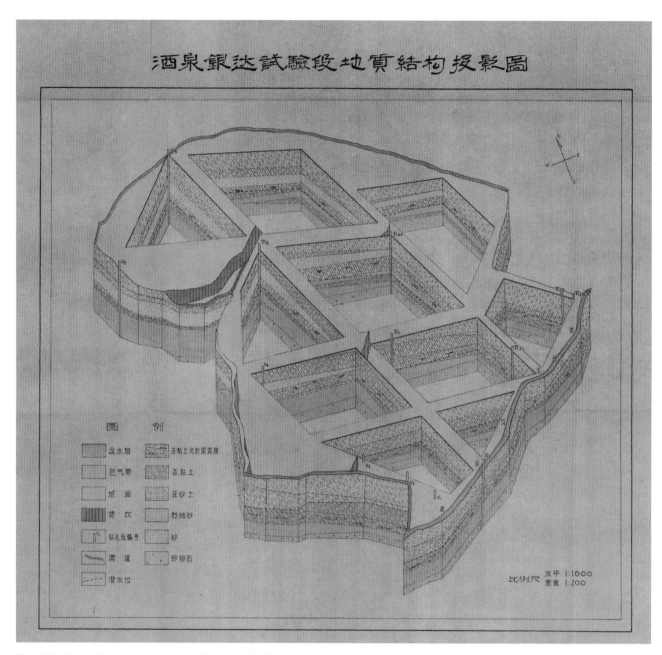

Fig. 4.39 Geological structure projection diagram of the Yinda experimental section of Jiuquan[39]

The diagram appears three-dimensional, with distinct, vivid layers of color. It includes a complete and detailed legend and other features(Fig. 4.39).

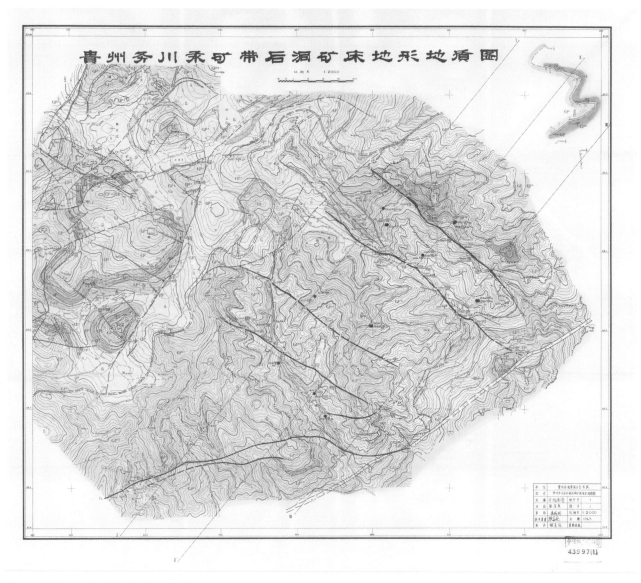

Fig. 4.40 Geomorphological and geological map of the Houdong mineral deposit in the Wuchuan mercury mining belt, Guizhou Province [40]

The map was created with clear lines in elegant colors rendered using a traditional Chinese brush painting technique. The color transitions are natural and smooth(Fig. 4.40).

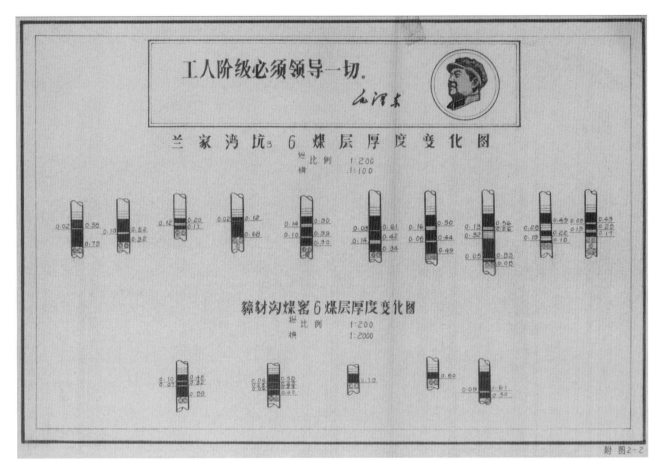

Fig. 4.41 Diagram of coal seam thickness variation of Pit 36 in Lanjiawan[41]

The columnar description is concise and easy to grasp(Fig. 4.41).

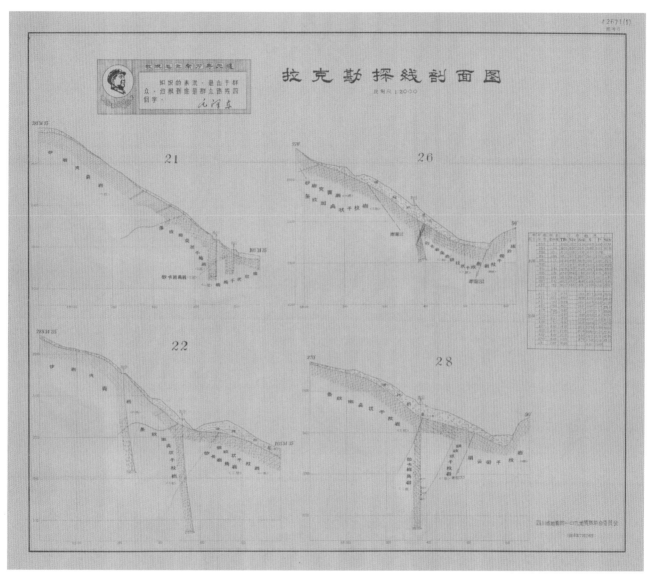

Fig. 4.42 Profile diagram of lake exploration line [42]

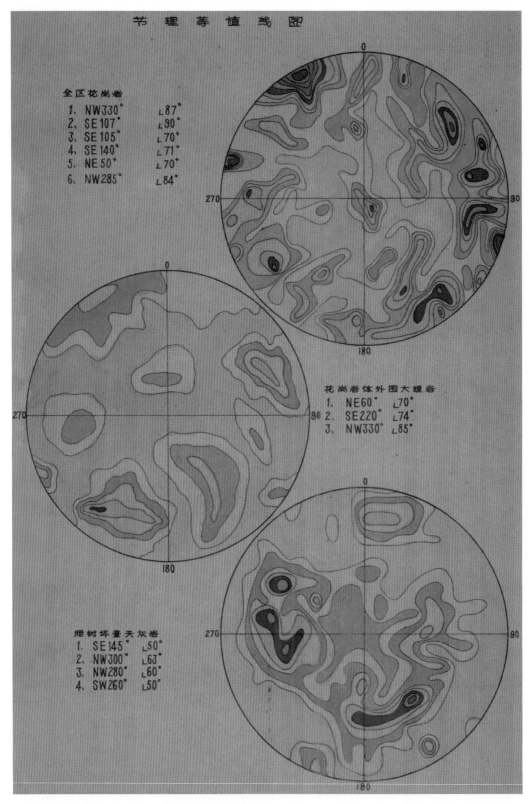

Fig. 4.43 Joint contour map for the report of the 1963 general survey on the Qitianling area of Hunan Province [43]

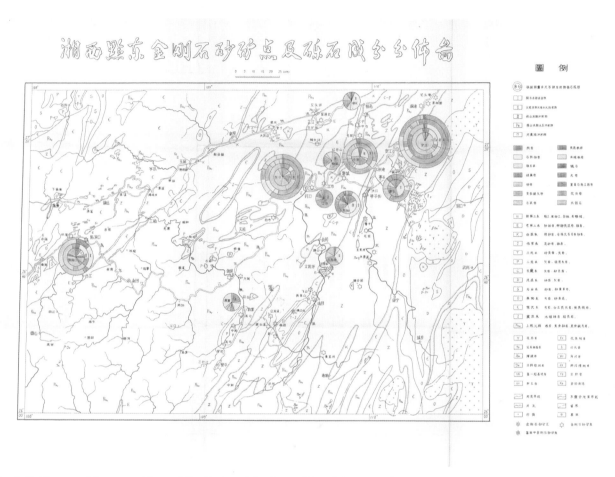

Fig. 4.44 Diagram of the composition and distribution of the diamond deposit in eastern Guizhou Province and western Hunan Province [44]

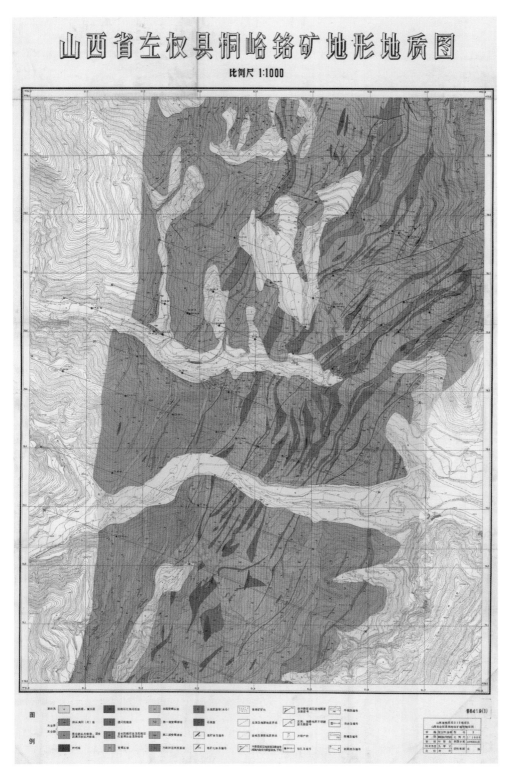

Fig. 4.45 Topographic and geological map of Tongyu chrome mine in Zuoquan County, Shanxi Province [45]

Contrasting colors were used to createan effect of color fluidity (Fig. 4.45).

Fig. 4.46 Schematic diagram of the intrusion of T1,2 and T3 in the western section of the Lingxiang rock mass, etc. [46]

Fig. 4.47 Hypothetic diagram of the development stage of volcanic subsidence of the Lujiang-Zongyang volcanic basin [47]

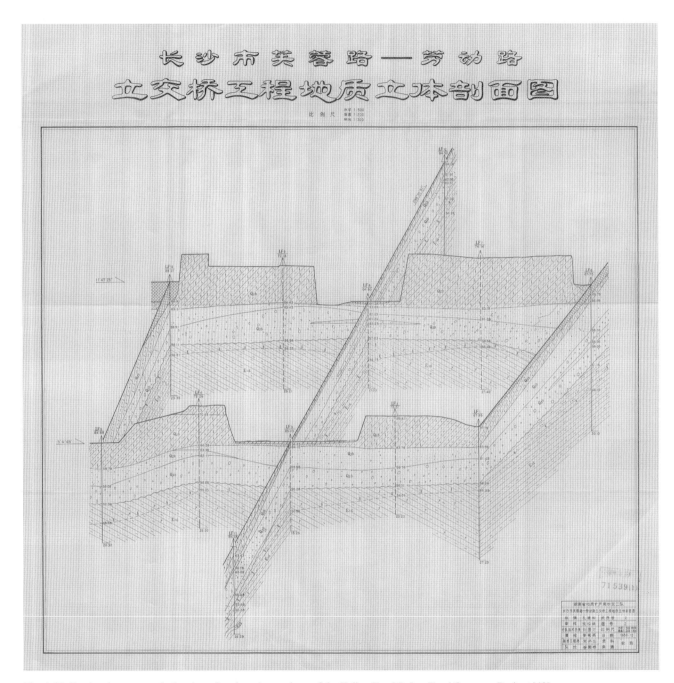

Fig. 4.48 Sectional axonometric drawing of engineering geology of the Fuling Road-Labor Road Overpass Project [48]

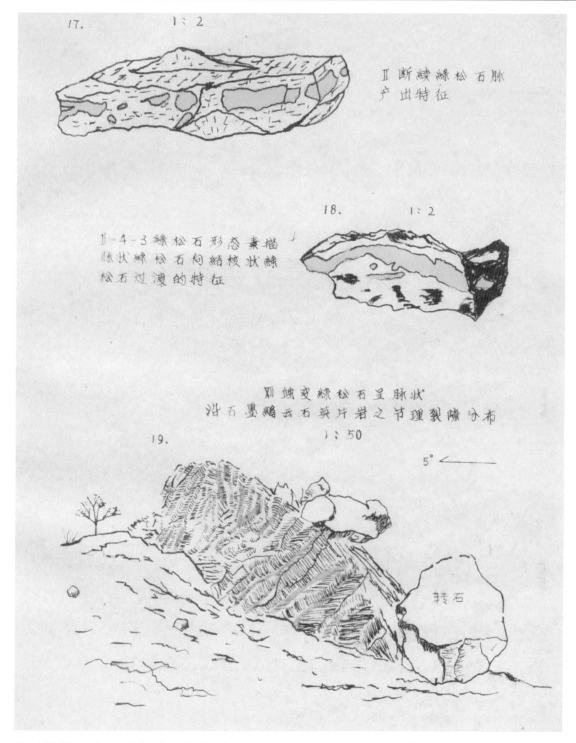

Fig. 4.49 Illustrations and sketches of minerals attached to report on geological turquoise survey at Mt. Duancen, Wulan County, Qinghai Province[49]

The texture is dense, orderly, and clean, with a subtle tint of color in certain areas, making the overall drawing precise and refreshing (Fig. 4.49).

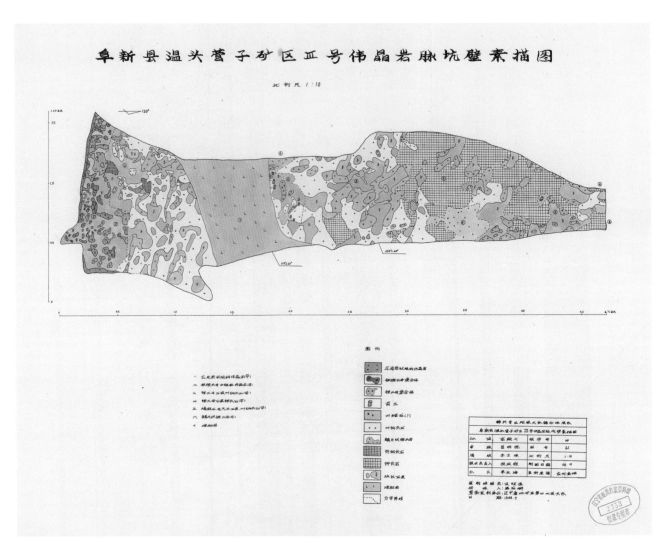

Fig. 4.50 Sketch of gallery wall of the No. 3 pegmatite vein in Wentouyingzi minefield, Fuxin County [50]

The sketch depicts richly complex structures, with distinct blocks and neatly labeled geological elements(Fig. 4.50).

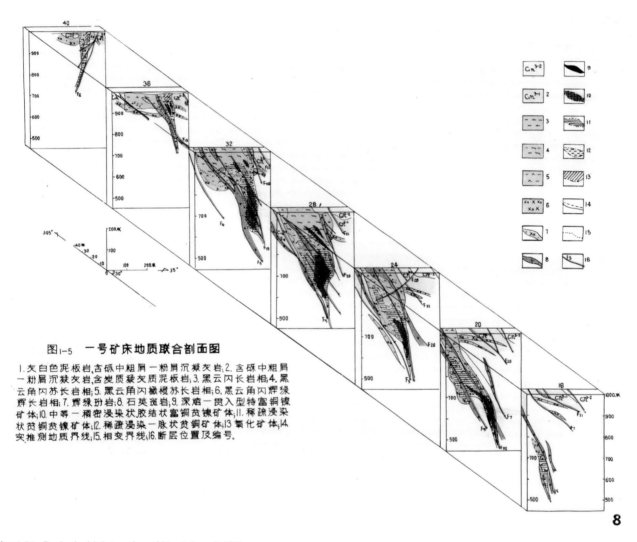

Fig. 4.51 Geological joint section of No. 1 deposit [51]

The diagram employs the perspective method to describe ore bodies(Fig. 4.51).

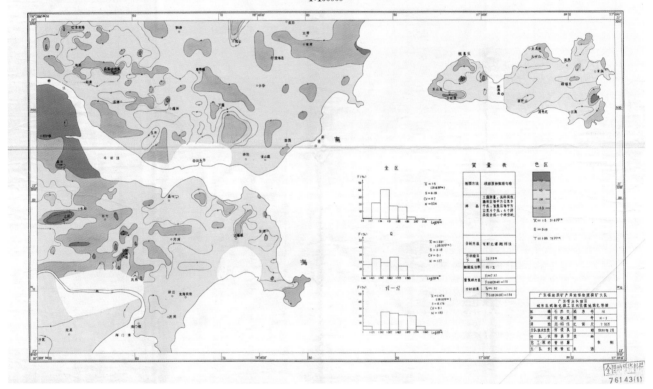

Fig. 4.52 Geochemical map of vanadium in the geochemical exploration site of an urban area of Shantou City, Guangdong Province [52]

The balanced and harmonious, brightly colored map is divided into four parts(Fig. 4.52).

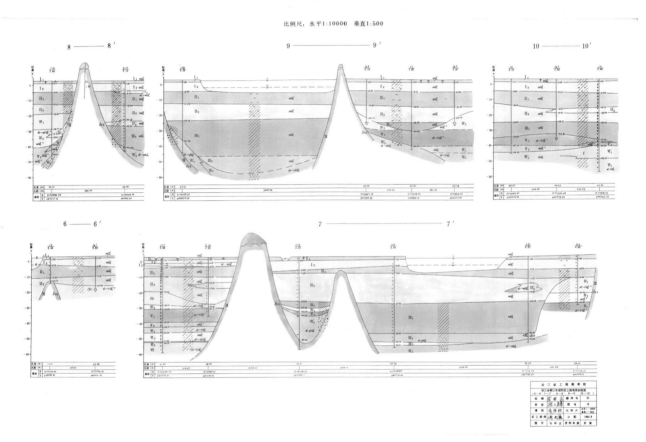

Fig. 4.53 Engineering geological profile of district planning of Jiaojiang City, Zhejiang Province [53]

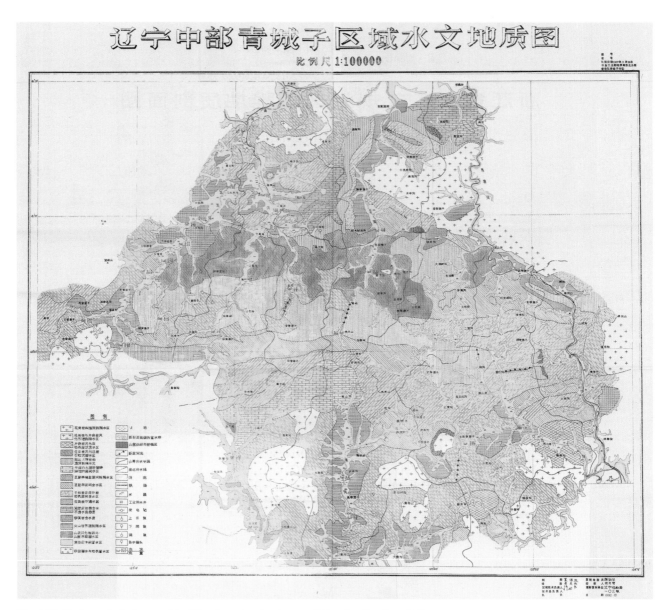

Fig. 4.54 Hydrogeological map of the Qingchengzi region in central Liaoning Province [54]

The map was drawn in optimal density with elegant colors(Fig. 4.54).

References

1. Geological Exploration Company of the Central South Branch of the China Nonferrous Metals Management Bureau. Geomorphological sketch of Shirenfeng Tungsten Mine, Shixing, Guangdong Province, (Sheet 1). 1954.doi:https://doi.org/10.12063/data.O.2018.NGA7933.T1.141.1.

2. Geological Exploration Company of the Central South Branch of China Nonferrous Metals Administration Bureau. Geomorphological sketch of Shirenfeng Tungsten Mine, Shixing, Guangdong, (Sheet 1). 1954. doi:https://doi.org/10.12063/data.O.2018.NGA7933.T1.142.1.

3. Geological Exploration Company of the Central South Branch of China Nonferrous Metals Administration Bureau. Geomorphological sketch of Shirenfeng Tungsten Mine, Shixing, Guangdong, (Sheet 2). 1954. doi:https://doi.org/10.12063/data.O.2018.NGA7933.T1.144.1.

4. The 625th exploration team of the Northwest Geological Bureau. Diagram of a seam columnar section of Yaojie Coal Mine. 1954. doi:https://doi.org/10.12063/data.B.2018.NGA3842.T1.2.1.

5. Engineering Geology Team of Nanjing University. Schematic diagram of the engineering geological map of areas south of the dam axis (river bed section). 1954. doi:https://doi.org/10.12063/data.D.2018.NGA8754.T1.17.1.

6. Chu Boyi. Geological map of areas peripheral to Gaositai, Chengde, Rehe.1954. doi:https://doi.org/10.12063/data.A.2018.NGA8904.T1.2.1.

7. XueJiaquan. Equal area chart of the Middle Jurassic Stratum of Yaojie Coal Mine in the Minhe Basin. 1954. doi:10.12063/data.O.2018.NGA8946.T1.21.1.

8. Yellow River Planning Commission. Agricultural utilization map of irrigated land in the Yellow River Basin. 1954. doi:https://doi.org/10.12063/data.O.2018.NGA9174.T1.9.1.

9. Huaihe River Commission of the Ministry of Water Resources Governance. Distribution of observation stations at various levels in the Huaihe River Basin in 1954.1954. doi:https://doi.org/10.12063/data.D.2018.NGA9641.T1.1.1.

10. Liu Hongxi. Topographic sketch of the Ningjiahe River Dam, Shawan County. 1955. doi: https://doi.org/10.12063/data.O.2018.NGA3870.T1.52.1.

11. TianZhengfang. Diagram of a continuous columnar section of Tuozu Iron Ore Mine in Butuo County.1955. doi:https://doi.org/10.12063/data.C.2018.NGA9919.T1.15.1.

12. Gao Lingyun. Geological profile sketch of Mt. Guaran-Mt. Yinshan.1955. doi:https://doi.org/10.12063/data.A.2018.NGA9957.T1.3.1.

13. Geological Survey Department of Xinjiang Petroleum Corporation, Ministry of Petroleum Industry. Sketch attached to final geological report on Subashi in central Mt. Huoyan, the Turpan Basin.1955. doi:https://doi.org/10.12063/data.O.2018.NGA10591.T1.23.1.

14. Liu Yanwen. Statistical diagrams of joints and fissures of the Tuanbaoshan Lead-Zinc Mining Area in Hanyuan County, Sichuan Province. 1955.doi:https://doi.org/10.12063/data.O.2018.NGA2596.T1.72.1.

15. Cao Yanzuo. Sectional diagram of a copper mine in the adjoining area of Yimen, Shuangbai, and Eshan Counties, Yunnan Province.1956. doi:https://doi.org/10.12063/data.A.2018.NGA9903.T1.157.1.

16. XiongMingying. Topographic and geological profile of Tuozu Iron Ore Mine in Butuo County. 1956. doi:https://doi.org/10.12063/data.C.2018.NGA9919.T1.17.1.

17. Liang Zhongjiang. Perspective view of the terrain in the vicinity of Maoming Oil Shale Field. 1956. doi:https://doi.org/10.12063/data.O.2018.NGA9976.F1.3.1.

18. State-owned, locally administered Liaoning Mining Company. Microscopic illustration attached to calculation table of a talc reserve in Fanjiapuzi. 1957. doi:https://doi.org/10.12063/data.O.2018.NGA11503.T1.75.1.

19. CaiJianjie. Perspective diagram ofore bodies near WestLake. 1957. doi:https://doi.org/10.12063/data.C.2018.NGA11926.T1.68.1.

20. Zhou Mingfen. Engineering geological map of pyrite mine in Mt. Liuhuang, Yingde, Guangdong Province. 1957. doi:https://doi.org/10.12063/data.C.2018.NGA11926.T1.80.1.

21. Thirteenth Sino-Soviet Cooperation Brigade. Series of geological maps of the Kashi-Akesu region of Southern Mt. Tianshan, Xinjiang(1). 1957.doi:https://doi.org/10.12063/data.A.NGA13916.T1.5.1.

22. Thirteenth Sino-Soviet Cooperation Brigade. Series of geological maps of the Kashi-Akesu region of Southern Mt. Tianshan, Xinjiang(2).1957.doi:https://doi.org/10.12063/data.A.2018.NGA13916.T1.6.1.

23. First Division of the 701st Team of the Xinjiang Nonferrous Metals Corporation of the Ministry of Metallurgical Industry. Schematic drilling diagram. 1958. doi:https://doi.org/10.12063/data.O.2018.NGA2054.Z1.14.1.

24. Yu Liansheng. Regional hydrological and geological map of the mining areas in the Suyukou, Yugou, and Nansi vicinities of Mt. Helan Mountain. 1958. doi:https://doi.org/10.12063/data.D.2018.NGA16319.T1.37.1.

25. Suqian Squadron of Huaiyin Survey Brigade, Jiangsu Province. Mineral geology report (cover). 1958. doi:https://doi.org/10.12063/data.O.2018.NGA21855.F1.23.1.

26. Du Zhenfang, Hu Qiangsheng. Cover of the report on mineral exploration in Liancheng County.1959. doi:https://doi.org/10.12063/data.O.2018.NGA17845.Z1.37.1.

27. Wan Shuqiong. Sketches of various polymetallic ore specimens from the Wujiang Mining Area of Leishan.1959. doi:https://doi.org/10.12063/data.C.2018.NGA21265.T1.21.1.

28. Wan Shuqiong. Sketch of Outcrop G1001 of the Dunan Mining Area of Leishan.1959. doi:https://doi.org/10.12063/data.C.2018.NGA21265.T1.29.1.

29. Gao Fuping, Cao Fangyun. Sketch of shallow well II/E1 of the lead-zinc mining area of Bangou. 1959. doi: https://doi.org/10.12063/data.C.2018.NGA22141.T1.11.1.

30. The 102nd Inner Mongolia Exploration Brigade, Yinchuan Petroleum Exploration Bureau. Sketches of the interface of J3a and J2c, among others.1959.doi:https://doi.org/10.12063/data.

O.2018.NGA21042.Z1.31.1.

31. Huang Jiqing, Zhao Qinglin, Xiao Xuchang, Jiang Chunfa, Ren Jishun, Cui Shude, XieDouke. Geotectonic map ofthePeople'sRepublic of China. Beijing, Geological Publishing House, 1960

32. Sun Deqin, TianRonghe, Li Zhongxue. Geomorphological map of the western Inner Mongolia Plateau (I-I',II-II' geomorphology sections). 1961. doi:https://doi.org/10.12063/data.A.2018. NGA26027.T1.13.1.

33. Qinghai Petroleum Administration Bureau. Quaternary geological map of the Qaidam Basin. 1961. doi:https://doi.org/10.12063/data. A.2018.NGA28587.T1.5.1.

34. Institute of Geology, Chinese Academy of Sciences. Illustration attached to report on a tectonic fracture system and engineering geological issues of the dam area of the Xinfengjiang River.1962. doi:https://doi.org/10.12063/data.O.2018.NGA32195.Z1.21.1.

35. Gao Huanzhang, Li Shihe, Wang Xinquan, Hu Zhenzong. Tectonic map of the Xi'an area. Beijing, Geological Research Institute of the Ministry of Geology. 1963 .doi:https://doi.org/10.12063/data. A.2018.NGA37738.T1.1.1.

36. Zeng Qingyong. Comparison of reservoir units of Strata P1, P2, and Tf in the Chongqing area.1963. doi:https://doi.org/10.12063/data.A.2018.NGA36941.T1.4.1.

37. Zhou Zhongmin, Liu Hongwen Kang Deyi, Ma Yijie, Zhuang Weifang. Sketch of Exploration ditch TQ1 at the crystal mining area of Miaogou.1968.doi:https://doi.org/10.12063/data.C.2018. NGA43081.T1.34.1.

38. MaShiqiong. Sketch of a geode in a mine block of the Gongli Crystal Mining Area, Luodian County, Guizhou Province.1964. doi:https://doi.org/10.12063/data.C.2018.NGA38692.T1.23.1.

39. Jiuquan Hydrogeological Station, Hydrogeology and Engineering Geological Team of Gansu Geological Bureau. Geological structure projection diagram of the Yinda Experimental Section of Jiuquan. 1966. doi:https://doi.org/10.12063/data.A.2018. NGA40321.T1.1.1.

40. Tang Yingsu. Geomorphological and geological map of the Houdong mineral deposit in the Wuchuan mercury mining belt, Guizhou Province. 1967. doi:https://doi.org/10.12063/data.C.2018. NGA43997.T1.1.1.

41. Revolutionary Committee of the 135th Brigade of Coalfield Geological Exploration Company, CoalMiningAdministration of Sichuan Province. Diagram ofcoal seam thickness variation of Pit36 inLanjiawan. 1968. doi:https://doi.org/10.12063/data. B.2018.NGA43349.Z1.14.1.

42. Revolutionary Committee of the 109th Geological Exploration Brigade, Sichuan Geological Bureau. Profile diagram of Lake Exploration Line.1968.doi:https://doi.org/10.12063/data.A.2018. NGA42671.T1.8.1.

43. The 235th Metallurgical Exploration Brigade of Hunan Province. Joint contour map for the report of the 1963 general survey on the Qitianling area of Hunan Province. 1970.doi:https://doi.org/10.12063/data.O.2018.NGA43569.Z1.25.1.

44. QuaternaryGlaciologyExpedition Team of the Institute of Geomechanics. Diagram of the composition and distribution of the diamond deposit in eastern Guizhou Province and western Hunan Province.1975. doi:https://doi.org/10.12063/data.C.2018. NGA54726.T1.5.1.

45. Sun Yunying. Topographic and geological map of Tongyu Chrome Mine in Zuoquan County, Shanxi Province. 1976. doi:https://doi.org/10.12063/data.C.2018.NGA56419.T1.3.1.

46. Iron-rich deposit exploration team, Hubei Institute of Metallurgical Geology. Schematic diagram of the intrusion of T1,2 and T3 in the western section of the Lingxiang rock mass, etc. 1978. doi:https://doi.org/10.12063/data.A.2018.NGA55440.Z1.11.1.

47. First Comprehensive Geophysical Prospecting Team, Ministry of Geology and Mineral Resources. Hypothetic diagram of the development stage of volcanic subsidence of the Lujiang-Zongyang Volcanic Basin.1983. doi:https://doi.org/10.12063/data.2018.NGA65065.Z1.33.1.

48. Li Juying. Sectional axonometric drawing of engineering geology of the Fuling Road-Labor Road Overpass Project. 1986. doi:https://doi.org/10.12063/data.D.2018.NGA71539.T1.2.1.

49. Sixth Geological Exploration Team of Qinghai Province. Illustrations and sketches of minerals attached to report on geological turquoise survey at Mt. Duancen, Wulan County, Qinghai Province. 1987. doi:https://doi.org/10.12063/data.O.2018. NGA70786.Z1.52.1.

50. Li Baozhu. Sketch of gallery wall of the No. 3 Pegmatite Vein in Wentouyingzi Minefield, Fuxin County. 1988. doi:https://doi.org/10.12063/data.A.2018.NGA33255.T1.67.1.

51. Fourth Geological Exploration Brigade of the Xinjiang Bureau of Geology and Mineral Resources. Geological joint section of No. 1 Deposit. 1989. doi:https://doi.org/10.12063/data.C.2018. NGA76263.Z1.8.1.

52. Zhou Zhaoxin. Geochemical map of vanadium in the geochemical exploration site of an urban area of Shantou City, Guangdong Province. 1990. doi: https://doi.org/10.12063/data.G.2018. NGA76143.T1.36.1.

53. Xu Guiyin. Engineering geological profile of district planning of Jiaojiang City, Zhejiang Province. 1990.doi:https://doi.org/10.12063/data.D.2018.NGA78758.T1.25.1).

54. Cui Zhenshu. Hydrogeological map of the Qingchengzi region in central Liaoning Province. 1992. doi:https://doi.org/10.12063/data. D.2018.NGA11275.T1.28.1.

Open Access This chapter is licensed under the terms of the Creative Commons Attribution 4.0 International License (http://creativecommons.org/licenses/by/4.0/), which permits use, sharing, adaptation, distribution and reproduction in any medium or format, as long as you give appropriate credit to the original author(s) and the source, provide a link to the Creative Commons licence and indicate if changes were made.

The images or other third party material in this chapter are included in the chapter's Creative Common slicence, unless indicated otherwise ina credit line to the material. If material is not included in the chapter's Creative Commons licence and your intended use is not permitted by statutory regulation or exceeds the permitted use, you will need to obtain permission directly from the copyright holder.

Leaping Forward Period (1995 to Present): Moving into Digital Mapping and Digital Cartography Era

Xuan Wu, Fanyu Qi, Guo Liu, Yuntao Shang, and Jie Meng

During the Ninth Five-Year Plan period, the Ministry of Geology and Mineral Resources deployed a pilot project for the construction of space database of 1:20,000,000. Since 2000, China Geological Survey has developed computer mapping systems in combination with regional geological survey. From 1999 to 2006, the China Geological Survey (CGS) completed a number of 1:250,000 Regional geological maps using 3S technology in the area of 152,000 km^2 in Qinghai-Tibet Plateau and its adjacent areas, in accordance with the unified mapping technical standards. This is an epoch-making project, marking the full completion of the medium-scale regional geological survey of China's land. What Lu Xun has said, "There is no home-made precise geological map in its territory and its city of a non-civilized country " has been fully realized.

Computer-aided mapping not only changes the traditional geological mapping method, speeds up the mapping speed, reduces the labor intensity, improves the quality of information transmission function and loading function of geological mapping, but also gives geologists sufficient time for comprehensive analysis and thinking, and improves the understanding of regional geological development and tectonic evolution. With the continuous development and improvement of computer mapping and 3S technology, China has possessed a large number of precise geological maps and databases, such as geological, mineral, hydrological, environmental, geophysical and geochemical exploration maps and databases of different scales, nationwide and regional. China's geological mapping has entered into the new era of information, electronic, networked and large numbers.

X. Wu (✉) · F. Qi · Y. Shang · J. Meng
Development and Research Center of China Geological Survey
(National Geological Archives of China),
Xicheng District, Beijing, P.R. China
e-mail: wxuan@mail.cgs.gov.cn

G. Liu
National Geological Library of China/Geoscience Documentation Center, China Geological Survey,
Haidian District, P.R. China

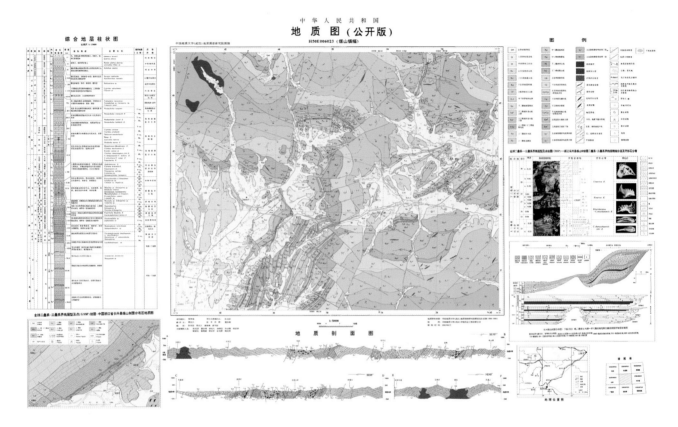

Fig. 5.1 Geological map of the People's Republic of China (H50E006023 Meishan Township Sheet) [1]

In July 1999, the China Geological Survey chose the Meishan section distribution area of Changxing, Zhejiang, as one of the first series of new national mapping projects. The projects have had an impact on the basic geological mapping of stratotypic sections and are significant at home and abroad. The Meishan Township sheet is the first candidate section of the international Changxing Stage standard section and the International Permian-Triassic Boundary Stratotype Section. That is, it is a support map of the global stratotype section and point (GSSP; commonly read as "Golden Spike") and is characterized by high-resolution, high-precision stratigraphic units (e.g., fossil zone, is ochronous event stratum, high-frequency cycle stratum, boundary stratum) and integrated stratigraphy(Fig. 5.1).

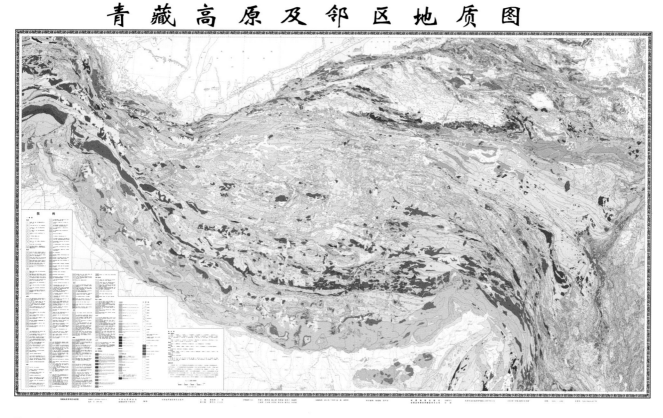

Fig. 5.2 Geological map of the Qinghai-Tibet Plateau and adjacent areas (1:1,500,000) [2]

This map comprehensively analyzes the special geological and geomorphological features of the Qinghai-Tibet Plateau unit in the context of the global tectonic pattern. In addition, it highlights recent achievements and insights of geological surveys and other scientific research. It also showcases outstanding achievements in regional geological surveys of and geological research in this area. As such, the map represents a new level of expertise achieved by Chinese geologists. Additionally, it represents the best map for international geologists seeking a comprehensive, objective, and detailed understanding of the general geological picture of the Qinghai-Tibet Plateau as well as the composition, structure, and evolution of each orogenic belt(Fig. 5.2).

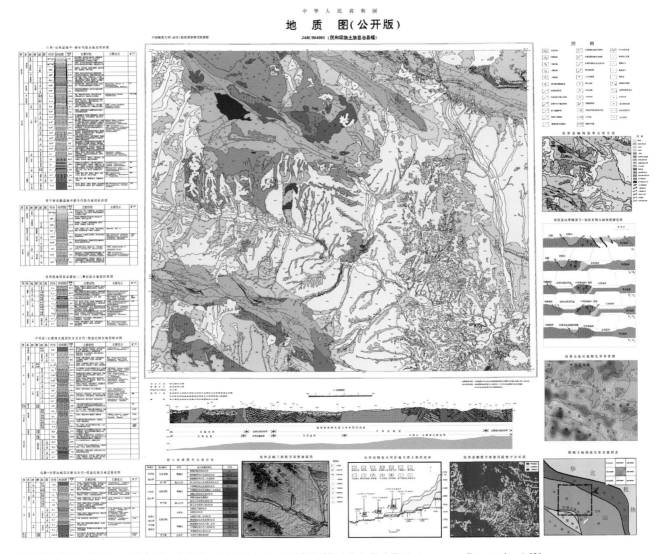

Fig. 5.3 Geological map of the People's Republic of China (J48C004001 MinheHui-Tu Autonomous County sheet) [3]

This map was designated a pilot digital geological map for western China by the China Geological Survey (October 2001). This pilot project at a scale of 1:250,000 established and improved the current technical requirements for digital mapping using an entire sheet at the same scale. In addition, it provided information and a foundation for teaching digital geologic mapping, the development of software and hardware for acomputer-assisted field mapping system and international exchange(Fig. 5.3).

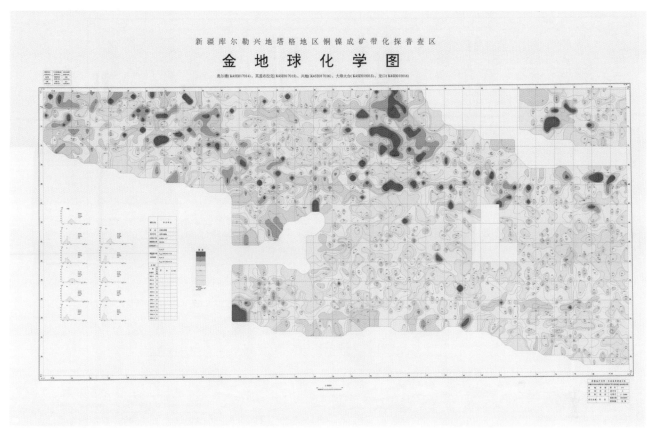

Fig. 5.4 Geochemical map of gold deposits in the general chemical prospecting area of the copper-nickel metallogenic belt in Taga and Korla, Xinjiang [4]

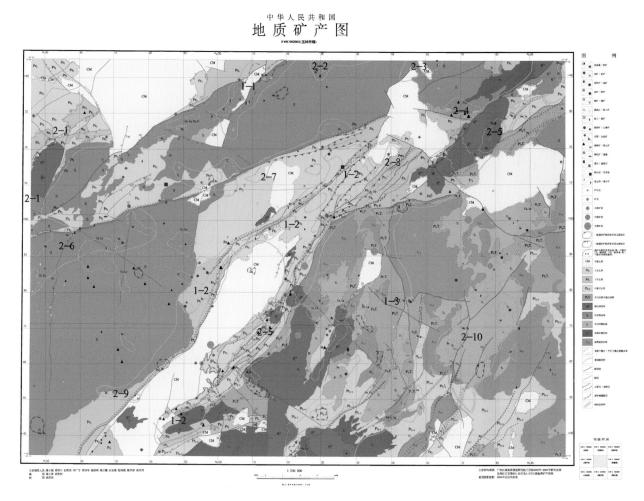

Fig. 5.5 Geological mineral map of the People's Republic of China (Yulin City sheet) [5]

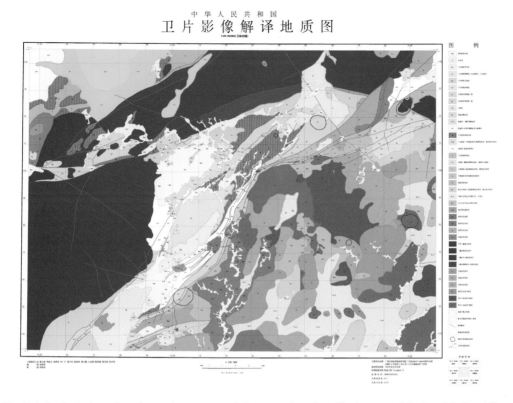

Fig. 5.6 Geological map based on a photogrammetric interpretation of satellite imagery of the People's Republic of China (Yulin City sheet) [6]

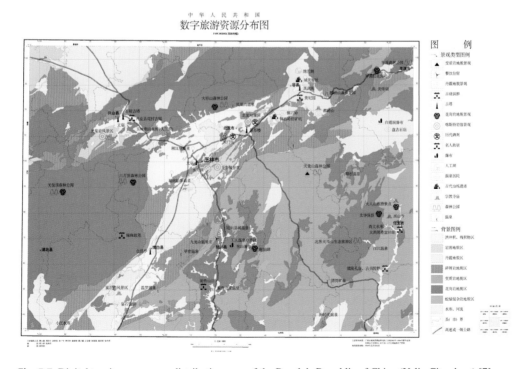

Fig. 5.7 Digital tourism resources distribution map of the People's Republic of China (Yulin City sheet) [7]

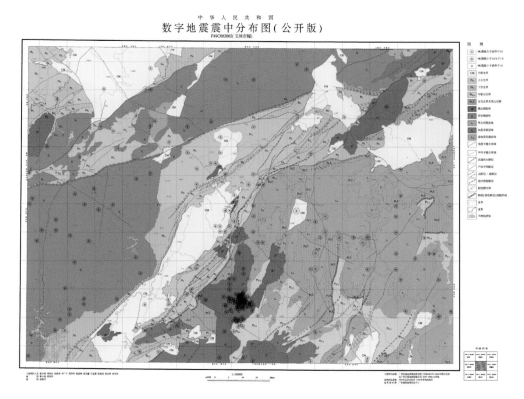

Fig. 5.8 Digital earthquake epicenter distribution map of the People's Republic of China (Yulin City sheet) [8]

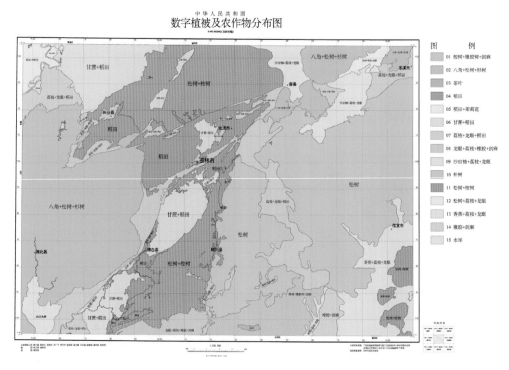

Fig. 5.9 Digital vegetation and crop distribution map of the People's Republic of China (Yulin City sheet) [9]

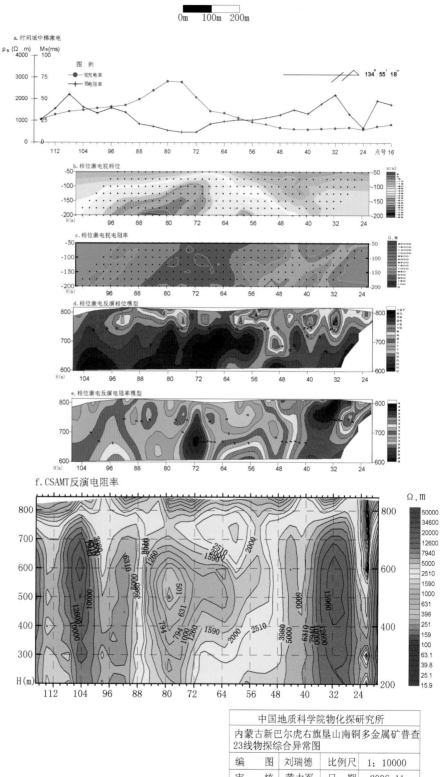

Fig. 5.10 Geophysical integrated anomaly map of the No. 23 Line for general prospecting of the copper polymetallic deposit south of Kenshan, Xin Barag Right Banner, Inner Mongolia [10]

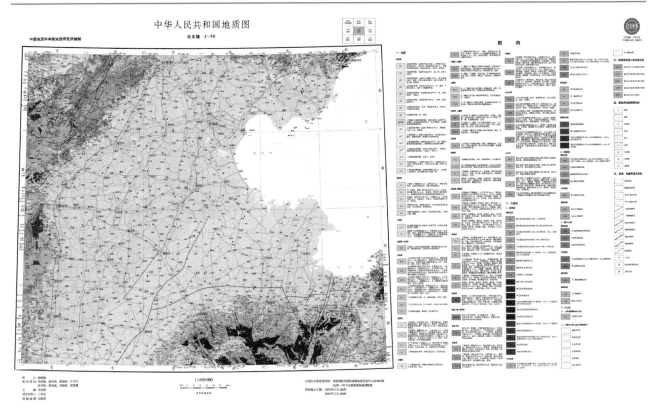

Fig. 5.11 Geological Map of China (J-50 Beijing sheet, 1:1,000,000) [11]

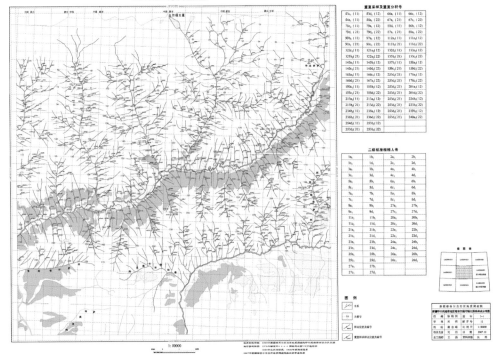

Fig. 5.12 Distribution map of geochemical exploration sites in the Kayilti River region, Hustogus District, Xinjiang [12]

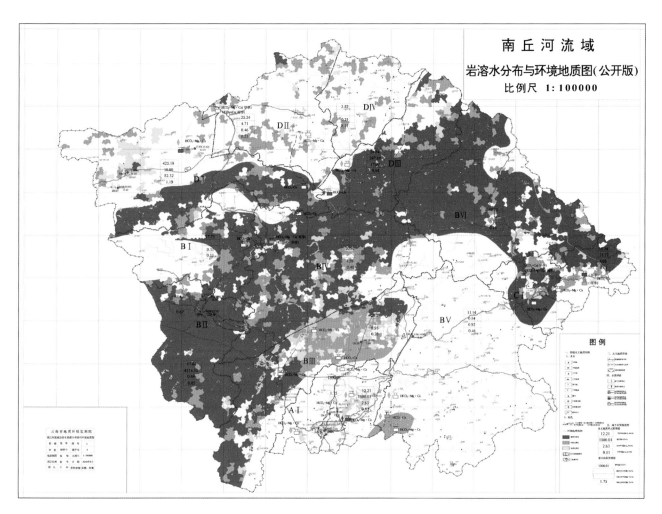

Fig. 5.13 Karst water distribution and an environmental geological map of the Nanqiu River Basin [13]

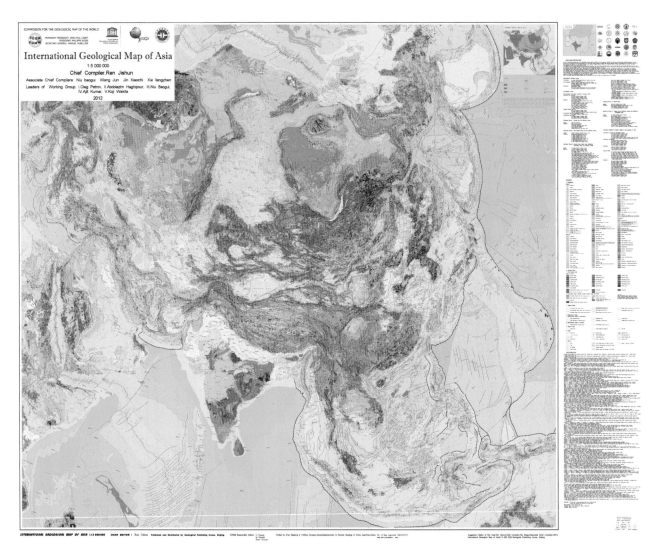

Fig. 5.14 International geological map of Asia (Scale: 1:5,000,000)[14]

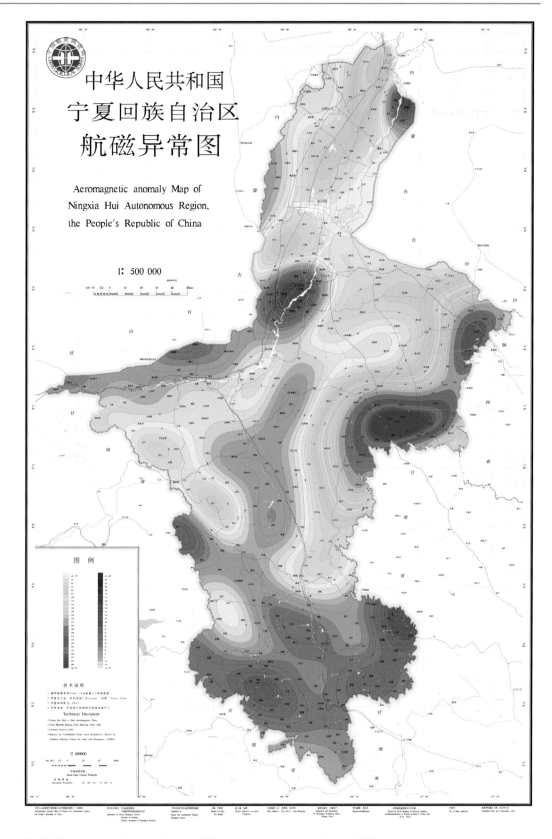

Fig. 5.15 Aeromagnetic anomaly map of Ningxia Hui Autonomous Region [15]

References

1. Zhang Kexin, HouGuangjiu, Tong Jinnan, SuoShutian. Geological Map of the People's Republic of China (H50E006023 Meishan Township Sheet). 2002. doi:https://doi.org/10.12063/data.A.2018.NGA122598.T1.1.1.

2. Pan Guitang, Ding Jun, Yao Dongsheng, Wang Liquan, Luo Jianning, Yan Yangji, Yong Yongyuan, Zheng Jiankang, Liang Xinzhi, Qin Dehou, Jiang Xinsheng, Wang Quanhai, Li Rongshe, GengQuanzhi, Liao Zhongli, Zhu Dicheng. Geological map of the Qinghai-Tibet Plateau and adjacent areas (1:1,500,000). Chengdu, Chengdu Map Publishing House, 2004.

3. Zhang Kexin, Zhu Yunhai, Lin Qixiang, Fan Guangming, Zhang Zhiyong, GuYansheng, Sun Ze. Geological Map of the People's Republic of China (J48C004001 MinheHui-Tu Autonomous County sheet). 2005. doi:https://doi.org/10.12063/data.A.2018.NGA122809.T1.1.1.

4. Zhao Jie. Geochemical map of gold deposits in the general chemical prospecting area of the Copper-Nickel Metallogenic Belt in Taga and Korla, Xinjiang. 2003. doi:https://doi.org/10.12063/data.G.2018.NGA95374.T1.2.1.

5. Qing Xiaofeng, Hu Guiang. Geological Mineral Map of the People's Republic of China (Yulin City sheet). 2004. doi:https://doi.org/10.12063/data.C.2018.NGA122581.T1.2.1.

6. Qing Xiaofeng, Hu Guiang. Geological map based on a photogrammetric interpretation of satellite imagery of the People's Republic of China (Yulin City sheet). 2004. doi:https://doi.org/10.12063/data.F.2018.NGA122581.T1.3.1.

7. Qing Xiaofeng, Hu Guiang. Digital Tourism Resources Distribution Map of the People's Republic of China (Yulin City sheet). 2004. doi:https://doi.org/10.12063/data.Z.2018.NGA122581.T1.4.1.

8. Qing Xiaofeng, Hu Guiang. Digital Earthquake Epicenter Distribution Map of the People's Republic of China (Yulin City sheet). 2004. doi:https://doi.org/10.12063/data.F.2018.NGA122581.T1.5.1.

9. Qing Xiaofeng, Hu Guiang. Digital Vegetation and Crop Distribution Map of the People's Republic of China (Yulin City sheet). 2004. doi:https://doi.org/10.12063/data.Z.2018.NGA122581.T1.6.1.

10. Liu Ruide. Geophysical integrated anomaly map of the No. 23 Line for general prospecting of the copper polymetallic deposit south of Kenshan, Xin Barag Right Banner, Inner Mongolia. 2006. doi:10.12063/data.F.2018.NGA123282.T1.12.1.

11. Li Tingdong, Ding Xiaozhong, Chi Zhenqin. Geological Map of China (J-50 Beijing sheet, 1:1,000,000). 2006. doi:https://doi.org/10.12063/data.A.2018.NGA108010.T1.1.1.

12. XieZhifeng. Distribution map of geochemical exploration sites in the Kayilti River region, Hustogus District, Xinjiang. 2007. doi:https://doi.org/10.12063/data.G.2018.NGA119040.T1.12.1.

13. Zhang Hua. Karst water distribution and an environmental geological map of the Nanqiu River Basin. 2010. doi:https://doi.org/10.12063/data.D.2018.NGA119772.T1.5.1.

14. Ren Jishun (Chief Compiler), NiuBaogui(Associate Chief Compiler). International Geological Map of Asia (1:5,000,000). Geological Publishing House, Beijing, 2012.

15. Fan Jinan, Yang Wenming. Aeromagnetic anomaly map of Ningxia Hui Autonomous Region. 2013. doi:https://doi.org/10.12063/data.F.2018.NGA132163.T1.4.1.

Open Access This chapter is licensed under the terms of the Creative Commons Attribution 4.0 International License (http://creativecommons.org/licenses/by/4.0/), which permits use, sharing, adaptation, distribution and reproduction in any medium or format, as long as you give appropriate credit to the original author(s) and the source, provide a link to the Creative Commons licence and indicate if changes were made.

The images or other third party material in this chapter are included in the chapter's Creative Common slicence, unless indicated otherwise ina credit line to the material. If material is not included in the chapter's Creative Commons licence and your intended use is not permitted by statutory regulation or exceeds the permitted use, you will need to obtain permission directly from the copyright holder.

Printed by Printforce , the Netherlands